HAUNTED HOTELS OF NORTHERN COLORADO

NANCY K. WILLIAMS

Published by Haunted America
A Division of The History Press
Charleston, SC 29403
www.historypress.net

Copyright © 2015 by Nancy K. Williams
All rights reserved

All images by Tom Williams unless otherwise noted.

First published 2015

Manufactured in the United States

ISBN 978.1.62619.933.0

Library of Congress Control Number: 2015943857

Notice: The information in this book is true and complete to the best of our knowledge. It is offered without guarantee on the part of the author or The History Press. The author and The History Press disclaim all liability in connection with the use of this book.

All rights reserved. No part of this book may be reproduced or transmitted in any form whatsoever without prior written permission from the publisher except in the case of brief quotations embodied in critical articles and reviews.

This book is dedicated to my granddaughters, each very special in her own way.

Amanda Williams, a tireless ghost hunter and precise photographer, who will attain her goals through determination and grit.

Ashlynne Jordan, patient and loyal, a perceptive friend, whose faithfulness and courage are admirable.

CONTENTS

Acknowledgements 7
Introduction 9

1. Meeker 11
2. Glenwood Springs 23
3. Redstone 41
4. Aspen 51
5. Leadville 63
6. Fairplay 75
7. Evergreen 91
8. Denver 99
9. Boulder 123
10. Eldora 135
11. Estes Park 143
12. Greeley 165

Bibliography 171
About the Author 175

Acknowledgements

A special thanks to my son, Tom Williams, for his photographic expertise and skill in capturing the charm and beauty of these historic hotels.

A big thank-you to all the people who shared their stories and experiences with us and helped make this book a reality.

My thanks to the hotel owners who allowed us to explore their halls, basements and attics and shared the tales of those guests who have never checked out and old employees who still help out.

A thank-you to the local librarians and researchers who have always pointed me in the right direction and provided the answers to tough questions.

Thanks and much appreciation to Becky LeJeune and Artie Crisp, commissioning editors, for their patience throughout this effort.

Many thanks to the paranormal investigators who have shared their findings and conduct their research with honesty and integrity.

Introduction

The Pikes Peak Gold Rush got off to a sputtering start—unlike the one to California in 1849. Eager gold seekers didn't stumble over fat nuggets or dip their gold pans into streams, instantly finding piles of gold dust. Most Pikes Peakers had no experience prospecting, no knowledge of geology and couldn't recognize a gold-bearing rock when they saw it. The rich veins of silver were often hidden above the tree line on towering mountain peaks.

The Pikes Peak treasure hunters were misled by newspaper headlines blaring, "The New El Dorado!" and "Gold! Gold! Gold!" They studied guidebooks written by dreamers who had never been west and bought everything they'd need to find gold—and a lot of stuff they didn't. These folks shopped at "Pikes Peak Outfitters" for Pikes Peak guns, Pikes Peak boots, Pikes Peak shovels, picks and gold pans. A disgusted newspaper editor suggested a need for "Pike's Peak goggles to help keep the gold dust out of the eyes of these foolish fortune hunters!"

Then they piled their unnecessary purchases into covered wagons, buggies and two-wheeled carts; painted "Pikes Peak or Bust" on them; and started on their great adventure! About 100,000 people joined this gold rush, and most of these eager souls had no comprehension of the distance they would travel or the obstacles that lay ahead. Some rode horses or mules, while others on foot struggled under huge backpacks. Unrealistic dreamers pushed their earthly goods along in wheelbarrows! The caravans crawled across the plains like dusty snakes, and at night, their campfires marked their trail, like beacons leading others west.

Introduction

When these Pikes Peakers reached Denver City in April 1859, instead of a boomtown, there was a scruffy camp of discouraged prospectors still hoping to make that lucky gold strike. There wasn't much gold in Cherry Creek, but a few discoveries were reported in the mountains. These newcomers were disgusted because they'd naïvely expected to strike it rich immediately. After a few days of unsuccessful panning in an icy creek, they were convinced that they'd crossed the plains on a fool's errand and started yelling "Humbug!"

Most of these eager gold hunters turned around and went back home; those who remained, persevered and bravely ventured into the Rockies fared better. They found fabulous veins of gold, and when the placer deposits finally ran low, some smart man realized that the pesky black sand filling their gold pans might be worth something, useful for more than chinking their log cabins; it was. That black sand and those unappealing gray rocks contained silver—tons of it—eventually turning Colorado into the shiniest state in the Union.

The Silver Decades were a time of excitement, wealth and immense growth. Towns popped up, and ramshackle mining camps grew into bustling cities, jumping with excitement and hope. Poor prospectors became overnight millionaires, the Silver Kings, whose mines produced unbelievable wealth. They spent the money as fast as it rolled in. Some built fabulous mansions and lived wildly indulgent lifestyles. There were more lasting achievements, too, as railroads began snaking across Colorado, despite the challenges of laying track over high peaks and blasting through the Rocky Mountains.

Wealthy men built plush hotels, featuring every modern convenience and catering to the very rich. Few remain today, lost to fire, gradual deterioration, foreclosure and destruction by the wrecking ball of progress, clearing the way for parking lots or strip malls. The surviving grand nineteenth-century hotels, landmarks of an exciting time in Colorado history, are full of the flavor and character of the past—and a ghost or two. Despite renovations and remodeling, wispy apparitions roam the halls and whisper in the dark. Dedicated employees are still on the job, unpacking your luggage, clanking dishes in the kitchen and operating the elevator that carries invisible passengers. Meet a shadowy tycoon keeping his eye on operations at his hotel, leaving an aroma of cigar smoke or cherry tobacco in his wake. Spend the night and savor the Victorian elegance of these hotels, whose ghostly guests have never checked out.

1
MEEKER

A plow and dreams of crops growing in the wide green valley of the White River drew Nathan Meeker to this region. He'd worked with Horace Greeley organizing the utopian Union Colony of Greeley in 1872, and he managed to obtain an appointment as Indian agent at the White River Ute Agency in 1878. He knew little about the Indians or their culture but was determined to turn them into Christian farmers. Meeker had no patience with the feelings or interests of the nomadic Utes, who'd lost their homelands to white settlers and been shuttled off to a reservation. The Indians viewed the plow and fences as symbols of oppression and refused to farm. They ignored Meeker's threats to withhold their food supplies or throw them in chains. When he promised to send them to Indian Territory, the savvy leaders knew he didn't have this kind of power and called him a liar.

Then he turned his attention to something the Utes prized almost as much as their families: their horses. For generations, horses had been vital to their nomadic existence, and they represented an individual's wealth. The Utes loved fierce horse racing and equally fierce betting. Meeker was certain that if the Indians weren't racing their horses, their days could be spent plowing and planting crops. He ordered the braves to kill their horses, showing his absolute lack of understanding of the nature of his charges. The furious Utes ignored him, and their distrust of the Indian agent increased.

Since he couldn't get rid of the ponies, Meeker decided to get rid of their pastures, making it harder to feed them. He moved the agency

headquarters several miles down the White River, placing it right in the middle of the lush meadows where the Utes pastured their horses. This angered them, and affairs reached a boiling point when Meeker took his plow to the Indians' carefully built racetrack and began ripping it up. A furious Ute leader yanked the plow away, and a loud argument ensued. Meeker telegrammed Washington, D.C., saying he'd been assaulted and asked for help. His first complaint was ignored, but as small groups of Indians drifted off the reservation for their customary fall hunts, Meeker realized he'd lost control of his charges. Again, he called for soldiers.

On September 29, 1879, thirty troopers from Fort Steele, Wyoming, led by Major Thornburg, crossed into the reservation near Milk Creek, where they were attacked by the Utes. The troopers were soon pinned down behind their wagons and piles of dead horses. An army scout sneaked through the Indians and rode 158 miles in twenty-eight hours to Fort Steele for help. Rescue troops started on a rapid, forced march toward the agency.

The trapped troopers ran out of food and couldn't reach Milk Creek to get water for the wounded. By the sixth day of the siege, their situation was desperate when General Merritt and 234 soldiers arrived from the fort. They drove off the Utes but were too late to save Thornburgh and 12 other troopers who'd been killed.

Meeker had been warned several times by local ranchers and even some Utes that trouble was coming, and they urged him to leave. Meeker ignored the warnings, signing a death warrant for himself and ten other men at the post. The Utes attacked the White River Agency on September 29, 1879, the same day as the battle at Milk Creek. They killed Meeker and all the men, burned the buildings and captured Meeker's wife and daughter, plus another woman and her two children. They held the captives for twenty-three days until Chipeta, Chief Ouray's wife, negotiated their release. General Merritt established a military post, called the Camp on the White River, about four miles north of the destruction. The troopers built adobe, brick and log barracks, stables, officers' quarters and barns around a square parade ground.

The Meeker Massacre brought an immediate public outcry and the trumpeted demand, "The Utes must go!" The whites remembered the 1876 Battle of the Little Big Horn, while the Utes were still angry over the massacre of women and children at Sand Creek in 1864. Chief Ouray and other tribal leaders went to Washington, D.C., where a treaty was hammered out. The Northern and Uncompahgre Utes would be moved to the Uintah reservation in northeastern Utah, while the Southern Utes would remain on their reservation in southwestern Colorado.

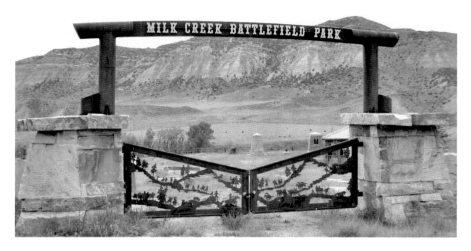

Milk Creek Battlefield, site of the last and longest conflict of the Indian Wars. The Utes besieged United States troops here from September 29 to October 5, 1879.

On September 7, 1881, the last of the Utes passed out of Colorado as the *Ouray Times* rejoiced:

> *Sunday morning the Utes bid adieu to their old hunting grounds and folded their tents, rounded up their dogs, sheep, goats, ponies and traps, and took up the line of march for their new reservation... This is an event that has been long and devoutly prayed for by our people. How joyful it sounds and with what satisfaction one can say, "The Utes have gone."*

Shortly after, Congress declared the Ute lands open for homesteading, and new towns were laid out. In the summer of 1883, the camp on the White River was dismantled, and the buildings were auctioned off, some selling for $50 to $100 apiece. This created a ready-made town that the settlers named "Meeker." The large log camp hospital became the first school and church; another barracks was converted into a store, and the parade ground was set aside as the town park. The Meeker Town Company sold lots, and businesses were started.

Homesteaders and ranchers came from Wyoming, Fort Collins and Denver. Everyone was in search of free land to start a farm or small ranch. In 1885, Meeker incorporated and had its first Fourth of July celebration, and the *Meeker Herald* printed its first edition. Rio Blanco County lines were

drawn by the legislature, with Meeker the county seat. For over twenty years, it was the only incorporated town in northwestern Colorado and was the supply center for surrounding farms and ranches.

Meeker became a major cattle-raising area, and ranchers drove their large herds east to the railroad at Rifle for shipment east. Trouble started in 1894 when a Wyoming rancher attempted to move his herd of sixty thousand sheep across the Colorado line. Ranchers and cowboys rallied together, and the sheep were turned back. Problems escalated between the two factions, and the Routt County Sheep War broke out, spreading into Rio Blanco County and farther east. There were several murders, and cattlemen, determined to keep the sheep off their grazing lands, ran thousands of woolies off cliffs or clubbed them to death.

When a herd of sheep had to be driven through Meeker, cowboys and citizens would block the herd. One smart sheep owner contacted the sheriff in advance. When his herd approached town, the sheriff, two marshals and four deputies were posted on all the street corners, watching as hundreds of woolies passed through town without difficulty.

The sheep wars in northwestern Colorado and Wyoming were especially violent and lasted well past the turn of the century. By 1921, the county's grazing land was being used equally by cattle and sheep, but friction over grazing rights continued.

Now and then, Butch Cassidy and his gang passed through town on their way to their hide-out in Brown's Hole. A rancher would notice some strange horses in his corral, while a few of his own stock would be missing. One old-timer said, "No one complained and pretty soon Butch would come back through, pick up his horses and return the ones he'd borrowed."

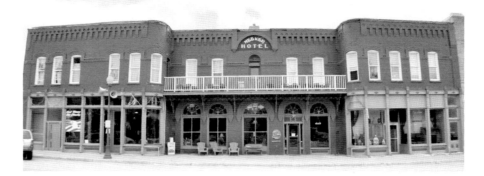

Meeker Hotel opened its doors in 1883.

There was little crime in Meeker until three junior members of Butch's gang decided to rob the bank in October 1896. The commotion drew every able-bodied man to the bank, and when the bullets stopped flying and the dust settled, there were three dead robbers and three wounded citizens. The dead men were placed in pine coffins and lined up for the usual postmortem photos before their quick burial.

The railroad never came to Meeker, so goods and supplies were shipped to Rifle by rail and then hauled in by wagons. Horseback and stagecoach were the main means of transportation until the first car, a Stanley Steamer, came to town around 1914. During the winter, cars and wagons were useless in the thick mud and heavy snow that blocked the roads, isolating the town.

Meeker looks much as it did a century ago, surrounded by cattle and sheep ranches. Hide-hunters, called "buckskinners," practically decimated the large herds of deer by 1910, and it took years to restore their numbers. Today, Meeker is well known for its huge herds of elk, deer and antelope.

Meeker Hotel

Susan Wright was first in line when the army auctioned off the adobe buildings of the post. A hardworking widow from South Carolina, she'd been the first woman to homestead near the White River and was the only woman in the newly formed Meeker Town Planning Company. She planned to turn the adobe barracks building into a comfortable hotel. She partnered with a friend, Charlie Dunbar, who bought another building, and it became the hotel's saloon.

During the first fall, Susan organized a community harvest so everyone would have enough food to get them through the winter. The weather was so severe that year that the town was snowbound, and eventually, everyone ran out of flour for bread making. Since there was plenty of cornmeal, Susan taught the women how to make southern johnnycakes. Everyone was thankful for johnnycakes and ate them in place of bread until spring, when the supply wagons finally got through the deep snow.

Susan and Charlie opened the Meeker Hotel in 1883, and as the only establishment within one hundred miles, it had plenty of business. Then she started a small café inside the hotel where travelers and guests could enjoy delicious meals. Charlie Dunbar, a professional card player, ran the hotel's saloon and gambling operations. He enjoyed attractive surroundings and

ordered a fancy French glass mirror that he placed behind the bar, greatly improving the saloon's appearance. The bar was stocked with every brand of liquor, and the partners bought beer by the wagonload, whiskey by the barrel and champagne by the case. Unfortunately, their partnership was short-lived, as Charlie got into an argument over a card game in the saloon. He was shot and killed on November 3, 1883, and was one of the first to be buried in the new cemetery.

Susan mourned her partner and closed the saloon for a while; then she decided she could work with Simp Harp. An enterprising man, Harp had started a stage and freight line, which worked out well because his stages brought travelers right to the hotel door. Both Simp and Susan were well liked by Meeker citizens, who often dropped by and never commented on her habit of smoking a cigar when she relaxed. She was known for her kindness and hospitality, never turning away anyone who was tired or hungry. Susan always found a warm spot for them to sleep—even if the hotel was full or the traveler had no money. Workingmen down on their luck were invited to share meals with the guests. If a cowboy drank too much in the saloon, she never sent him out into the night; instead, he slept upstairs in a small room on the back hall. Many Meeker children had winter gloves thanks to Susan Wright, who was known by everyone as the "Mother of Meeker."

In 1891, Harp sold his share of the hotel to Susan and moved to Craig to start another stage line. Susan's brother, Reuben Bell, who had lost his Creede saloon in the big fire of 1892, became her new partner. That same year, Susan developed a lingering illness from which she never recovered. She died that winter and was buried in the Meeker Cemetery. Reuben built a little house over her grave because Susan had always said that she "didn't want snow on her grave." The following spring, he had her body sent back for burial in her native South Carolina. The entire town mourned Susan, recalling her generosity and many kind deeds.

Susan Wright left all her possessions to her brother, Reuben, who began enlarging the hotel and adding a second story. There were three long halls with bedrooms on either side and five arched windows in front. Knowing the dangers of fire, he added a double brick firewall to the entire building. Unfortunately, he didn't modernize the plumbing, and there was no running or hot water. All water for the guests' use had to be carried up the long staircase, and hot water for bathing was heated in the kitchen. Sleeping rooms were heated by small, coal-burning stoves, and every morning, the janitor brought fuel upstairs and carried the ashes down. With so many stoves going on cold winter nights, it's a wonder the hotel didn't burn down

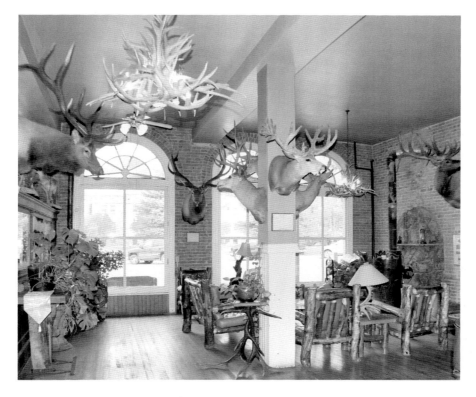

Some trophy mounts in the hotel lobby are over one hundred years old.

anyway. Reuben completed the addition with a large piece of flagstone engraved with the hotel's name and "R.S. Ball" in smaller print below. This was placed on the front of the building between the windows.

In 1901, Teddy Roosevelt, the newly elected vice president, spent three weeks hunting mountain lions and big game in the White River country around Meeker. His party of guides, cowboy wranglers and Colorado politicians spent some jolly nights at the Meeker Hotel. Teddy bagged a trophy mountain lion weighing over 220 pounds, setting a world record, and townspeople came by to shake his hand, slap his back and congratulate him.

In 1904, Ball added two-story additions on each side of the original building. Over 200,000 bricks were hauled to Meeker by freight wagon since there was no railroad. The Ball family ate with the guests in the café/dining room, where each linen-covered table seated eight. There were a few

permanent boarders, and meal times were lively as everyone chatted and shared stories. No one remained a stranger long.

Reuben furnished the hotel with oak furniture and had "R.S. Ball" carved neatly into every piece of furniture. Today, some homes around Meeker still have some of these antiques. The hotel had a front lawn surrounded by a low, white fence, and Mrs. Ball planted flowers, which the children gathered for dining table bouquets. Reuben put up a swing and built a treehouse in a box elder behind the hotel where the town's children had a great time. The youngsters were forbidden to use the lobby staircase, but they were allowed to visit the kitchen, where the cook always had treats of cake and pie.

In 1918, Ball moved the café next door and decorated it in the popular Art Deco style. The café served many well-known personalities: Franklin

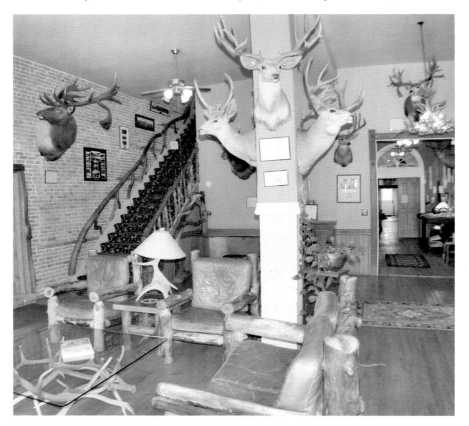

Teddy Roosevelt spent jolly evenings with friends here after a day hunting bears or mountain lions.

and Eleanor Roosevelt dropped by, and Gary Cooper often grabbed a bite when he was filming around Meeker. Silent movie cowboy Buddy Roosevelt, a Meeker native, was a regular customer.

Reuben operated the hotel for over thirty years and contributed plenty of trophies to the collection in the lobby from his trips to Alaska. Ball finally sold to the Dunns, who ran the hotel another thirty years. It was renovated and placed on the National Register of Historic Places in 1980. It sold once again in 1996.

Today, historic photos of Teddy Roosevelt, Gary Cooper and other celebrities from the past decorate the warm brick walls of the lobby. Massive, century-old trophies of elk and deer, Boone and Crockett caliber, overlook the lobby with its tin ceiling. The original floor of polished oak planks creaks and groans underfoot just as it has for over 130 years. Upstairs, the pine floors are original, and the claw-foot and cast-iron bathtubs, made in 1883, are also original. Gary Cooper stayed in the guest room that bears his name, and Eleanor Roosevelt liked a front room with windows overlooking Main Street. She often visited her son and grandchildren, who lived in the area, and hosted teas for friends at the hotel.

The hotel's guestbook in the White River Museum contains a mysterious signature. Scrawled boldly on a page is the name "William H. Bonney, July 1889." This name was often used by Billy the Kid, believed to have been killed in July 1881 in New Mexico by Pat Garrett. Many think Billy escaped, and this adds to the mystery surrounding the young outlaw.

Ghosts

This historic hotel is home to at least four ghosts: a little girl, a middle-aged woman, a gambling man and a soldier. Guests and employees have had many strange experiences; most said they weren't frightened, but they are aware of these spirits. A longtime hotel manager commented, "It can be scary just because it surprises people, but it's nothing like the things in the movie, *Poltergeist*."

The hotel's handyman, Rik, remarked, "I'm the ultimate skeptic, but there is something going on here. It's a comforting feeling. It's not foreboding. It's a welcoming, additional presence." He continued, "I'm here all the time—and you certainly get a feeling that somebody or something is with you." Doors open quietly after they've been firmly closed, and when a door has been locked, the knob turns back and forth. Occasionally, there's

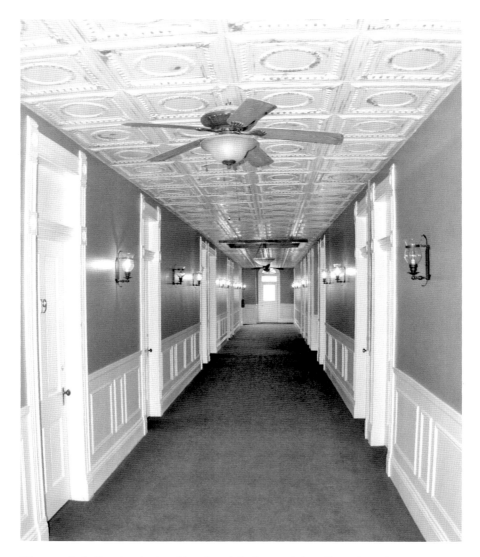

The upstairs hall and entire hotel has the original pressed tin ceilings. Gary Cooper stayed here when filming around Meeker.

a faint, unexplained fragrance upstairs, and several guests have heard footsteps pacing back and forth in the room next to theirs.

We sensed a presence in the hall upstairs and in one room in the portion of the building that hasn't been renovated. Many people think Charlie Dunbar, who was killed downstairs in his saloon, is still keeping

an eye on the hotel. Sometimes early risers find a cheerful fire burning in the lobby's old wood stove even though everyone denies lighting it. Occasionally, a woman feels an unseen hand on her arm or elbow escorting her down the staircase.

Children have often seen the apparition of a little blond girl who wants to play but then quickly fades away, leaving youngsters puzzled or frightened. Ghost hunting guests have picked up a lot of electromagnetic field (EMF) activity in the upstairs hall, on the lobby staircase and in room 15.

Everyone says these spirits are not frightening like demons or restless, wandering souls seeking eternal rest. They are watchful and protective, looking out for the hotel, its guests and those who work there.

2
GLENWOOD SPRINGS

"Yampah," or "Big Medicine," a sacred place where the Utes soaked their tired muscles, healed their wounds and rejuvenated their bodies and spirits in its hot springs and vapor caves. Around 1878, James Landis, an unsuccessful Leadville prospector, made his way over Independence Pass and discovered the lush valley along the Grand River. He cut grass in its green meadows and reluctantly headed back to Leadville, where there was a market for this hay. The following spring, Landis returned, filed a claim on 160 acres and built a small log cabin near the hot springs.

Isaac Cooper, a Civil War veteran, found relief from the misery of his combat injuries in the hot springs. He was joined by John Blake and prospectors who'd been looking for silver on the Flat Tops. They bought James Landis's land, including the Yampah Hot Springs, forming the Defiance Town and Land Company. The town site quickly grew into a tent city of shacks, dugouts and small cabins. Sarah Cooper shared her husband Isaac's dream of developing Defiance into a world-class hot springs resort but knew changes were needed. Pointing at the shabby tent grocery, tent saloon and dirty clothes being washed in the hot springs, she sniffed, "Not this way! Not with this name!" Mrs. Cooper persuaded everyone that the first step toward a world-class resort was a new name, and the town became Glenwood Springs and was designated as the Garfield County seat.

Since money was needed to develop a resort, Cooper approached Walter Devereux, the richest man around, busily making money in Aspen silver and New Castle's coal. Devereux was too busy for a resort dream but never

discarded Cooper's ideas. By 1885, Glenwood Springs had grown to five hundred people, with several stores, a bank, plenty of saloons and a red-light district. John Blake acquired a common-law wife, Gussie, who established the first house for "soiled doves." She and handsome John had a tumultuous relationship, and after an especially vitriolic argument, she closed up shop and headed east. John, never one to miss an opportunity, rented Gussie's "house" to the new county officials. The following spring, Gussie returned unexpectedly to find her place of business occupied by politicians. Ever resourceful, she built a small addition to her "courthouse" and resumed business. For a year, the county commissioners shared space with the brothel, complaining bitterly. The county clerk fumed every month as he wrote the rent check to a madam.

The Colorado Midland Railroad was laying its standard-gauge tracks over the Continental Divide, heading for Aspen; next, rails would be laid down the valley to Glenwood Springs. At the same time, the Denver and Rio Grande Railroad (D&RG) was constructing a narrow-gauge line through the rocky canyon of the Grand (Colorado) River toward Glenwood Springs. The race was on, and the victor would capture lucrative contracts to haul coal from large deposits near Glenwood to the smelters in Leadville and Aspen.

Walter Devereux had never forgotten Isaac Cooper's dream of a luxurious hot springs resort and knew a railroad would help this dream become reality. While the two railroads battled through mountains and canyons, Devereux organized the Glenwood Light and Water Company, building a hydroelectric plant to turn on the town's electric lights. Then he purchased the Yampah Hot Springs and designed a European-style spa around the world's largest hot springs pool.

The D&RG blasted through solid rock cliffs towering over one thousand feet above the turbulent river and completed two tunnels. The tracks were laid over rail beds with retaining walls constructed by Italian stonemasons and Chinese and Mexican laborers. These walls were built without mortar and are still in use today. The third tunnel was 1,331 feet long and was the most difficult to blast; the explosions rattled Glenwood Springs. Citizens came to watch, and when they saw a final blast create "light at the end of the tunnel," everyone cheered.

On the evening of October 5, 1887, with loud whistles echoing triumphantly through the tunnel, the D&RG's two-engine workhorse train chugged into Glenwood Springs, puffing clouds of steam and smoke, pulling five passenger coaches and railroad president David Moffat's luxurious

private car. The cheers of the huge crowd were deafening as Governor Adams, numerous dignitaries and railroad officials were welcomed by the mayor. Fireworks were punctuated by loud bursts of "giant gunpowder" used in blasting, and the hills glowed with huge bonfires. Everyone lit candles in front of their homes, and the town blazed with light. The Glenwood Brass Band led a torchlight parade past businesses, decorated with banners welcoming the railroad, to the Hotel Glenwood. There were speeches, a fine banquet, congratulatory toasts and a celebration ball that lasted well into the night. The celebration continued the following day with more firecrackers and enough blasts of giant powder to drive another tunnel. After two years of construction and $2 million, Glenwood Springs finally had a railroad.

Isaac Cooper celebrated the arrival of the train but didn't live to see his vision of a luxury resort become a reality. He died on December 2, 1887, and everyone mourned the loss of this well-liked town father. Businesses closed while his body lay in state in the lobby of the Hotel Glenwood. The passing of gambling gunman Doc Holliday was noted with much less sorrow. He'd arrived in May 1887 and dealt faro at a saloon, but by September, he was so weak from advanced tuberculosis that he could hardly get around. He celebrated his thirty-sixth birthday with friends at the Hotel Glenwood, where he lived. On November 8, 1887, bedridden Doc drank a glass of whiskey; looked around in amazement; whispered, "This is funny"; and breathed his last, dying in bed with his boots off. He was buried in Linwood Cemetery, and the citizens of Glenwood erected an impressive monument at the grave.

Once in Glenwood Springs, the D&RG wasted no time laying tracks to Aspen, and just before Christmas 1887, the Colorado Midland Railroad whistled into town. Both railroads began running special trains for festivals, celebrations, picnics and ball games. Spectator trains followed racing bicyclists closely so fans could cheer on their favorites, and tourist excursion trains with open observation cars ran regularly through the canyon.

The fishing train left Glenwood Springs early on Sunday mornings, loaded with fishermen, tackle boxes and fly rods. It stopped at favorite fishing holes along the Frying Pan River, and promptly at four o'clock in the afternoon, the train came back down the valley, whistling loudly, picking up fishermen who were loaded with the day's catch and tales of the big ones that got away.

Both railroads ran weekend laundry trains to and from Glenwood. Miners jumped on the train in Aspen or Leadville for $1.50 round trip and, once in town, got a bath in the hot springs, had their laundry done

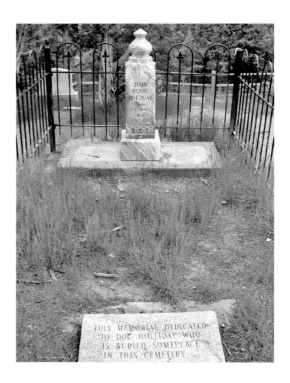

John Henry "Doc" Holliday died of tuberculosis in Glenwood Springs on November 8, 1887, with his boots off and was buried in Linwood Cemetery.

and then spent the evening in one of the saloons drinking, gambling or visiting Gussie's girls. Glenwood's law officers were always happy to see the laundry train full of exhausted but happy revelers pull out of town on Sunday evening.

The population of 2,500 increased on rowdy weekends. When celebrants got out of hand, they paid their fines by working instead of being lodged in the jail. They joined the "jailbird rock-pile gang" building enormous rock walls to change the Grand River's course and protect the hot springs pool from floodwaters. The giant pool was constructed around the huge hot water spring, which produced over three million gallons of water a day. No other spring could compare with its natural heat of 126 degrees Fahrenheit, requiring the installation of a cold-water fountain in the center of the pool to moderate the temperature.

After the pool was completed in 1888, a luxurious sandstone bathhouse was built, containing forty-two elaborate Roman-style baths with porcelain tubs, plus rooms for relaxing and massages. The second floor was an exclusive gambling casino restricted to wealthy gentlemen, required to wear white tie and tails when testing their luck. Health-seekers lounged

in the vapor caves, breathing thick, sulfur-smelling fumes. They refreshed themselves with goblets of hot mineral water that could be drunk, gargled or snuffed. These mineral waters were bottled and sold worldwide by the spa's physician as cures for every ailment suffered by humans. The grounds around the bathhouse were beautifully landscaped with colorful flower gardens, shade trees, sparkling fountains, lush lawns and pools of ducks and black and white swans.

Next, Devereux built a fine hotel, the equal of the world-class spa. Construction took two years, and the grand opening of the Hotel Colorado on June 11, 1893, was a gala affair. Devereux's brothers built a racetrack, a polo field and a golf course. They recruited local cowboys, taught them the rules of polo and had the first game in 1890 before a loudly enthusiastic audience. The cowboys often defeated their opponents, and their tough little ponies were a quite a match for the sleek thoroughbreds. Polo provided lucrative opportunities for the cowboys, who trained their horses for polo and sold them for high prices to eastern visitors.

In 1893, after the opening of the Hotel Colorado, Congress repealed the Sherman Silver Purchase Act, devastating silver mining. While there were

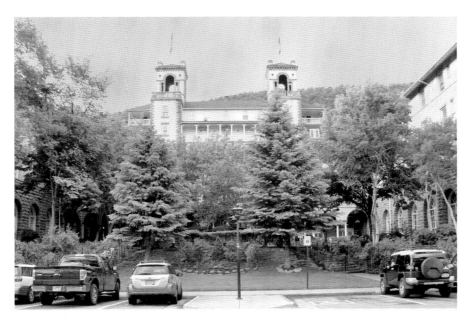

Hotel Colorado is modeled after Italy's Villa de Medici with a central court of flower gardens and trees.

serious hardships in many Colorado towns, Glenwood Springs lived on, attracting wealthy British tourists and newly rich Americans.

During World War I, visits from tourists gradually declined, and Prohibition dealt the deathblow to the numerous saloons. A few became pool halls, but droves simply closed as gambling halls, slot machines and poker tables also disappeared. As the dry years wore on, the number of illegal stills and speakeasies increased. For every hidden still that was destroyed, two more sprang up, and there was always a ready supply of bootleg whiskey at the town's dance pavilions. When Prohibition was finally repealed in 1933, bars opened once again in hotels and restaurants, but the Depression times were hard. The Civilian Conservation Corps (CCC) worked in the White River Forest, and the Works Progress Administration (WPA) helped set up towers for a chairlift on Red Mountain as interest in skiing grew.

During World War II, the Hotel Colorado was commissioned as a naval hospital, and trains carrying wounded men arrived daily. Tourism picked up during the 1950s as people boarded the Denver and Rio Grande's California Zephyr Vista Dome Coaches for a trip through the spectacular canyon, now known as Glenwood. The Grand had been renamed the Colorado River.

In 1956, a large group of businessmen purchased the hot springs pool complex and began remodeling it. In 1960, President Eisenhower authorized funds to build an interstate highway between Denver and Cove Fort, Utah, another step toward an interstate highway system. Building the highway through the mountains and Glenwood Canyon was a monumental task, finally completed in October 1992, with a price tag of nearly $500 million. In August 1998, Glenwood Caverns, containing two of the largest cave rooms in the state, reopened.

Hotel Colorado

The splendid Hotel Colorado sits on a bluff overlooking the Colorado River and the Hot Springs Resort. Modeled after Italy's sixteenth-century Villa de Medici, the six-story sandstone and cream brick building is U-shaped. Its twin towers shelter a central court with colorful gardens and fountains. When a foreign dignitary visited, his country's flag was flown from one of the towers, while the Stars and Stripes waved from the other.

The hotel's showpiece was a magnificent Florentine fountain that sent sparkling streams of water 185 feet into the air, higher than the towers, and

iridescent with colored lights. A stone walkway through terraced gardens and lily ponds led to the Hot Springs Resort.

Walter Devereux spent $850,000 building the hotel, whose luxurious accommodations were judged the equal of Denver's Brown Palace Hotel. The railroads ran special trains from Denver, Pueblo, Aspen, Leadville and Colorado Springs, bringing distinguished guests from Colorado and across the nation for the gala opening in June 1883. There was swimming in the hot springs pool, tours of the vapor caves, horse races and a polo match at the polo field. In the evening, there was a lavish banquet in the grand dining room with speeches and many toasts, followed by a night of dancing. It was a sparkling night with the hotel, gardens, promenades and fountains illuminated with lights.

The hotel's east wing contained luxurious suites, billiard rooms for the ladies and gents, a nursery and a playroom. The west wing had a sunny music room, smoking and card rooms, a grand ballroom and the dining room, where formal attire was required for dinner.

The Palm Garden/Aquarium Room featured a twenty-five-foot-high waterfall cascading over rocks into a pool stocked with fresh trout where guests could catch dinner. Natural light streamed through the glass ceiling, giving the illusion of dining in a quiet glen.

Two grand staircases led from the lobby to the 207 rooms upstairs, or guests could use the two hydraulic elevators. Guest rooms contained ornate fireplaces or were heated with steam, and most had sinks with running water. In an era when indoor plumbing was considered a luxury, there were fifty-nine private baths and sixteen shared public bathrooms. The rooms were furnished in the Victorian style with brass bedsteads, Brussels carpet, velour drapes and lace curtains. The hotel had modern electrical wiring and was the first hotel on the Western Slope to have electricity.

Front desk staff was imported from London, while sixty chambermaids and waiters came from Boston. Glenwood residents were not hired to care for the guests, and they couldn't patronize the hotel. The equal of posh eastern resorts, the hotel attracted the wealthiest, most fashionable members of elite society. Often, there were as many as sixteen palatial, private railroad coaches of rich socialites parked on the special tracks nearby. This was a convenience for distinguished guests like presidents, the Mayo brothers, the Chicago meatpacking millionaire Jonathan Armour, Jay Gould and his family, Diamond Jim Brady, railroad genius David Moffat and Evalyn Walsh McLean, owner of the Hope Diamond.

Teddy Roosevelt often visited on his hunting trips, and he was always accompanied by an entourage of friends, naturalists, photographers,

newsmen and as many as five hunting guides. In April 1905, as president, his party increased in size with a secretary, numerous clerks and stenographers, plus the Secret Service. The Hotel Colorado was known as the "Little White House" with a telegraph line directly to Washington, D.C., during the president's three-week hunting trip.

The Teddy bear legend began one day when a glum Roosevelt returned empty-handed from bear hunting. The hotel maids decided to cheer him up with a stuffed bear they made from scraps and pieces of fur. Roosevelt's daughter, Alice, was fond of this little bear and named him "Teddy." It was a sweet beginning for the Teddy bear, the world's favorite toy.

Teddy hosted a banquet and stag party for his hunting guides, cowboys and his many friends in the hotel's dining room. When he noticed the wranglers and guides were flummoxed by the array of silverware, he yelled, "Just grab the implement nearest you, boys!" The dinner was a roaring success, and everyone had a great time whooping it up. The president swore them all to secrecy about the jokes and stories they told that night. When the entourage piled on the train for the return trip to Washington, D.C., they were joined by a lively fox terrier named Skip. He'd been the littlest in the pack of thirty hunting dogs, and when he tired out, he hitched a ride behind the president's saddle. Roosevelt was very fond of Skip, and when the dog was presented at the depot, the president gladly tucked this farewell gift under his arm and hopped aboard.

In 1909, newly elected president William H. Taft stopped at the hotel on his way to the Western Slope. He dined on fresh Rocky Mountain trout and wild raspberries for breakfast but turned down a swim in the hot springs pool, explaining, " It's much better for a fat man like myself not to bathe in public."

During Prohibition in 1923, when President Harding came through Glenwood, he became quite huffy when he learned Glenwood Springs still had about fifty saloons. He ordered the train backed up the canyon to Dotsero to avoid having anything to do with liquor.

After his nomination for vice president, Franklin Roosevelt spent time relaxing at the hotel and soaking in the hot springs. In August 1939, President Hoover enjoyed a brass band reception and a lunch for four hundred guests and Republican leaders at the hotel. A reception followed so the citizens could meet the president.

In 1926, Tom Mix, cowboy star of the silent westerns, arrived in grand style at the hotel with his cast and production staff of fifty-five people to make a movie. They traveled in two luxury coaches plus two more carrying luggage, equipment and young John Wayne, a prop man on his first film

job. While Mix was filming in the canyon, trains with open observation cars hauled star-struck fans out to see the action. Spectators cheered when the star, riding his horse Tony, dashed across the narrow top of Shoshone Dam and jumped onto a moving train to catch the bad guys.

Brothers Bert and Jack Alterie, friends of Al Capone, blew in from the Windy City and set up headquarters at a ranch near Sweetwater Lake. Since Jack's wife was the daughter of a well-known Leadville bootlegger, they had a ready supply of illegal booze. Jack, nicknamed "Diamond Jack," wore flashy diamond rings, a diamond watch, a jeweled belt buckle and sparkling diamond studs on his western shirts. He topped off this glittering ensemble with a high-crowned, ten-gallon cowboy hat and a brace of pistols worn in crossed gun belts. The brothers were big spenders and made their way around town in a long, cream-colored convertible, accompanied by burly bodyguards. Occasionally, they entertained Al Capone, Legs Diamond and various Chicago gangsters at the Hotel Colorado.

During the 1920s, Al Capone, accompanied by a large entourage of sinister-looking bodyguards, often pulled up at the hotel in a shiny black Lincoln. He attracted so much attention that the manager erected a special canopy on the east entrance to make the arrival of these notorious guests less noticeable. Sometimes Capone bought all the seats in a Pullman car on the night train to Glenwood Springs and spent a week in the hotel's most luxurious suites.

When a bellboy delivered a case of booze to the Presidential Suite, he saw a group of men playing cards. He recognized Al Capone, Baby Face Nelson and Machine Gun Jack McGurn, who masterminded the Bloody St. Valentine's Day Massacre. The bellboy said the tip he received was enough to put him through college. Capone occasionally used the freight elevator to escape when federal officers raided the hotel.

In 1943, when the Hotel Colorado was commissioned as a navy hospital, the old building was "modernized," a new heating plant was installed and the plumbing and wiring updated. Unfortunately, during the modernization, many fine features of the hotel were lost as ornate fireplaces were plastered over, and custom stone mantelpieces were ripped out. Marble sinks and bathtubs were removed and replaced with easily disinfected showers and toilets. Carpets were torn up and replaced by linoleum, and the original antique furniture was taken away and never seen again. The vapor caves and hot springs pool were closed to the public, used only by military patients. The bathhouse became a clinic and physical therapy area, handling over six thousand military patients.

During the 1920s, a canopy was erected over the east entrance to decrease attention to the arrival of Al Capone and other notorious gangsters.

After the war, the hotel returned to private ownership, but it had lost much of its grandeur. In 1971, a new owner restored some of the hotel's Victorian character, removed the parking lot covering the grassy courtyard, unearthed fountains, planted gardens, replaced carpeting and peeled away layers of paint covering oak and pine panels. In 1977, the hotel was listed on the National Register of Historic Places. In 2007, it was included with the National Trust's Historic Hotels of America, and it is a National Historic Landmark.

Ghosts

This hotel is haunted by several ghosts who have been encountered numerous times by employees and guests. Over the years, the third and fifth floors have experienced the most paranormal activity. When the

hotel was being spruced up during the 1980s, workmen put up new wallpaper in room 551, but the next day, they found it lying in piles on the floor. The wallpaper was replaced, but the next morning, it was on the floor again. After several more attempts, the manager decided "someone" was not happy with this wallpaper. That night, three different rolls of paper were left on the bed. The next morning, one roll was on the bed; the others were tossed about. The selected wallpaper was hung, and it remains on the walls to this day.

When a painter was working in room 551, the water faucet in the bathroom kept turning on, and the room's doors opened and shut by themselves. The lights flickered on and off while he was painting, and he had trouble getting the job done. When another maintenance man worked in this room, he was startled several times by glimpses of a man slipping through the door. When he checked, the room was empty. He was also startled when the bathroom door slammed loudly several times—there were no drafts—and he was so frightened his hair was standing straight up.

Guests in room 551 might find their luggage unpacked and their clothes hung in the closet. Keys and personal items are often moved about; the TV turns on and off, changing channels randomly. There are knocks on the door during the night, but no one is ever there. One night, a guest was awakened by a knock, and looking through the peep hole, he saw the door across the hall standing open. It led to the attic and was always locked, with the key kept by maintenance. Since they'd gone home, who had unlocked the door? A psychic has sensed the presence of a workman from 1893 who lives in an area across the hall from room 551 and "wants to be left alone."

An especially helpful spirit on the third floor is kept busy unpacking guests' luggage and hanging their clothes in the closet. One family spent a weekend at the hotel and when checking out, left a tip and special thanks at the front desk for the housekeeper. She'd put their clothes away daily, packed their luggage for the trip home and even cleaned the children's tennis shoes.

In 1994, a food and beverage manager, staying in room 558, was upset when his TV suddenly began changing channels, and he often smelled tobacco smoke in the room. Another guest staying in room 558 closed the window before going into the bathroom to take a shower. When she came out, the window was open and a lamp and a book were lying on the floor. Closing the window, she picked up everything and returned to the bathroom. When she came out, the books and lamp were again on the floor, and the window was wide open. Things were constantly moved about during her stay.

Room 242, where guests get frequent whiffs of cherry tobacco, and someone unseen moves toiletries and keys about.

There's an armoire in room 555 that has a disappearing-reappearing bullet hole in its mirror.

During the 1960s, a couple named Carter managed the bar and restaurant and lived with their children in room 555. Mrs. Carter pooh-poohed the spooky experiences of other employees and told her children that there were no ghosts. Several years later, she returned to see old friends at the hotel and revisit her family's quarters. The TV suddenly began flipping through channels, and the door banged open several times while she was there.

The bell tower, room 661, the Molly Brown Suite, was named after Margaret Brown, the heroine of the sinking *Titanic*, who often joined her wealthy eastern friends at the hotel. This suite has a lot of paranormal activity, and many guests have awakened to see a woman in a flowered dress standing at their bedside. One man became ill while staying in this suite, and his wife, believing fresh air would help his recovery, opened all the windows before going downstairs. A strange woman came in, closed all the widows, scolding, "If you want to get well, you need to avoid drafts!" His wife returned to find

the suite was closed up tight. The same thing happened the next day when the wife opened the windows and went shopping. The third day was a repeat of the other two, but by now, his wife was becoming exasperated with this interfering woman. Thankfully, the following day, the husband was greatly improved and left the suite with his wife. When the houseman took them to the depot for the trip home, the man told him to thank this woman who'd been "so helpful" when he was ill. The houseman laughed, saying she must have been a "good spirit."

A little girl in an old-fashioned dress, who is about seven years, bounces a ball through the halls, and some guests have awakened to find her standing by their beds. Psychics say this is the spirit of a child who fell off the balcony years ago while chasing her ball. A guest snapped a photo on the fifth floor that shows a filmy image of a young girl in a light-colored dress, and she sent a print to the hotel.

A workman in room 328 heard a woman's voice say hello. He went into the bathroom and heard the greeting again. He went into the hall and asked the housekeepers if they'd popped into the room or seen anyone. Nothing. He returned to the room, and when he started to climb out the window to his ladder, an unseen hand suddenly grabbed the back of his shirt and pulled him back in the room. There was no one there. The hall door to room 328 refuses to stay locked when the guests are out, and several have complained that it's standing wide open when they return.

The basement has always been an especially spooky place, even before the laundry became the morgue during the hospital years. Employees have seen an old cowboy in 1880s clothes and some Native American women here, but they always vanish.

A security guard leading a tour through the basement heard two women talking and a typewriter clacking in the laundry. When the group entered, the room was dark and empty. The laundry is locked at night, but it's often found open in the morning with the lights on. One night after an event, the banquet manager took used linens to the laundry, but the door was locked. She went upstairs to the front desk, got the key and returned to find the laundry open with the lights on. Returning the key, she remarked that the houseman had opened the laundry for her. She was surprised to learn he'd gone home two hours before the incident, and his set of keys were locked in the safe. The laundry seems to be an ongoing issue, as it is often found open after being locked for the night.

One night while making his rounds, the security guard heard the exercise equipment being used in the basement workout room. The room

was dark, but the sounds continued until he turned his flashlight on the Nautilus equipment. The noise stopped. No one was in sight, but something cold brushed past him, causing his hair to stand on end.

The hotel's original elevators are still operational, and sometimes they run on their own. The houseman secured one in the basement only to turn around and see it rise, carrying several women in nurses uniforms. Some nights, the elevator moves busily from floor to floor when no one has called for it, and it has no visible passengers.

During the summer of 1943, a nurse named Bobbi became involved in a love triangle with two officers. When one of the men found out, in a fit of jealousy, he bludgeoned her to death. The navy hushed up the murder and immediately shipped both men out to cover up the crime, releasing the news that the thirty-six-year-old nurse had died from a septic sore throat. This was reported in the August 3 *Glenwood Post*, but local employees of the hospital whispered about what had really happened. Many people believe Bobbi is still around.

When two employees of the hotel's marketing firm were decorating the lobby for the holidays, they used fourteen-foot ladders to adorn the large columns. They both noticed a strong smell of gardenia perfume near the ceiling and said it was so powerful that it gave them chills. When they came back down the ladders, there was no fragrance at floor level. A sweet gardenia fragrance is noticed in the dining room at lunch and dinner and often at Sunday brunch. The scent seems to move about and is often stronger near one table.

A woman on her way to the second-floor ice machine peeked through a small window in the elevator door and started screaming. She ran downstairs to the desk, saying she'd seen a woman's body covered in blood, lying in a laundry cart. When everybody peeked in the window, they saw nothing—no body, no laundry cart.

Peculiar things often occur during the night—especially at the front desk between 2:00 a.m. and 4:00 a.m. One night, a man in Victorian clothing was sitting outside, near the front door, smoking a cigar. He turned and watched as an employee crossed the lobby, but neither spoke. When the nervous worker looked back, the man had simply disappeared.

Personnel at the front desk often see a stocky man wearing charcoal gray pants, a red plaid vest and a black tie. Sometimes he bustles about or he may approach them and then simply vanish. A night auditor swore he saw this gentleman in the lobby and then he disappeared. Kitchen workers have encountered him, and when they offer help, he simply vanishes.

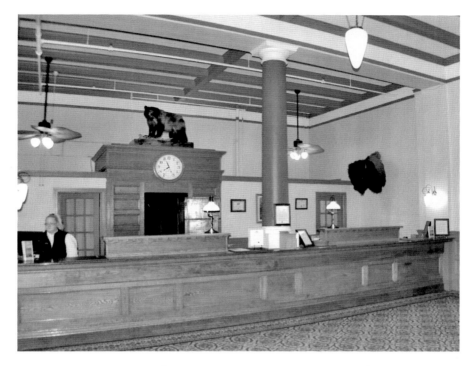

Peculiar things happen at the front desk, as drawers open by themselves, files disappear mysteriously and a Victorian gentleman bustles about.

In 1993, two photographers were taking pictures of the lobby and fireplace for a marketing brochure. When the photos were processed, one showed a misty gentleman sitting in a chair near the piano, reading the newspaper. This image appeared in only one photo, and experienced experts ruled out any flaws in the film but weren't able to explain this image. For two weeks after this photo shoot, hotel employees and guests noticed flashing lights rocketing about the lobby, day and night.

Night clerks and auditors working at the front desk have had strange, frightening experiences like drawers opening by themselves, files disappearing, pages turning and papers being shuffled by invisible fingers. They've felt light touches when no one's about, and the chandelier near the desk has a life of its own, spinning about randomly. Playful spirits have sent items sailing from the top of the safe behind the desk. The door to the nearby Colorado Room opens and closes during the night, but no one's around.

When the security manager and another employee entered the kitchen on their nightly rounds, an entire rack of glasses began shaking violently

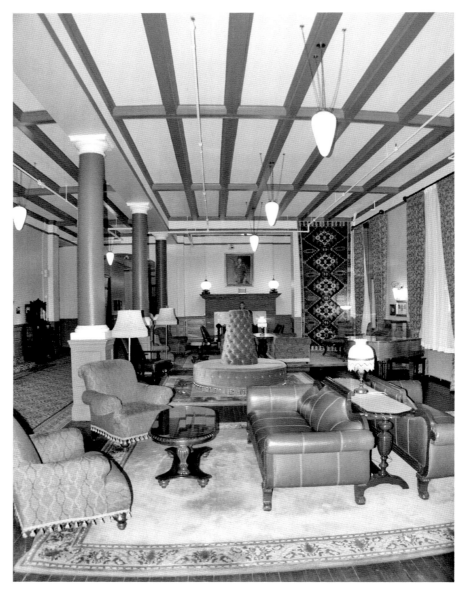

A Victorian gentleman was photographed reading the newspaper in the lobby. His cigar smoke is often noticed as he passes by.

and didn't stop until they left the kitchen. Pots and pans are moved about mysteriously and fall off the shelves by themselves. A box of cereal flew from a shelf, across the kitchen and struck a cook in the chest. Front desk personnel hear strange noises, like the sharpening of knives, coming from the kitchen when no one's working.

Early one morning, the cook heard dishes being stacked in the Devereux Room, but no one was there. When he returned to the kitchen, the sounds resumed, and again, there was no one. This happened several times, and suddenly, a mist appeared in the kitchen. As the entire staff watched, it swiftly moved across the dining room and disappeared through a closed door.

When a security guard was repairing a kitchen window, a large heavy box on the opposite side of the room started moving slowly toward him. He noticed the movement but continued to work, ignoring the box. By the time he completed the repair job, it was sitting next to him on the floor. To show he wasn't afraid, he gave it a good kick on his way out of the kitchen. The box didn't budge—it was full of heavy cans of tomatoes.

Several paranormal groups have conducted investigations at the hotel and reported a great deal of activity. CCPI Paranormal Investigations picked up EMF fluctuations near the attic door across from room 551 and snapped a digital photo of a very large orb here. When the investigators returned to their room to compile their data, the lights began flickering. This became so disruptive that one investigator finally asked the spirit to let the lights alone so they could get their work done—the lights stayed on.

When an electrician completed a repair, the problem persisted despite his efforts to correct it. Frustrated, he called the maintenance supervisor and explained his problem. The supervisor joined the electrician and then yelled loudly, "Walter, quit fooling with the electrical wires. We need this to work." Just like that, everything started—problem fixed.

Whiffs of cigar smoke are picked up throughout the hotel, in the halls, the lobby, around the front desk and in guest rooms—when no one is smoking. One of the cigar-smoking ghosts is Walter, the man who built this hotel and the Hot Springs Resort and is still keeping an eye on everything.

3
REDSTONE

The treasure of Redstone was not sparkling gold or silver but shiny black coal. A large deposit was exposed by an avalanche that narrowly missed two prospectors. Disgusted with their find, they were thrilled to sell it to John Osgood for $500 around 1880.

Osgood formed the Colorado Fuel Company in 1883, and within five years, he controlled over five thousand acres of coal in the Elk Mountains and at Crested Butte and Trinidad. In 1892, he merged Colorado Fuel with another corporate branch to form Colorado Fuel and Iron Company (CF&I). His company dominated the fuel trade, and he established a coal empire of thirty-eight mine camps working sixty-nine thousand acres of coal, fourteen coal mines and eight hundred coke ovens, capable of producing twenty-five thousand tons of coke monthly. Osgood took over General William Palmer's Colorado Coal and Iron steel mills at Pueblo, the only integrated steel works west of the Mississippi. Next, he bought the Aspen and Western Railroad, which provided the first rail service into the Crystal Valley. His railroad hauled coal from his mine at Placita to the beehive-shaped coke ovens at Redstone, where it was converted into coke for his steel mills.

Osgood's company produced 75 percent of Colorado's coal. At forty-two, Osgood was a multimillionaire, the Fuel King of the West. Irene de Belote, a sly southern belle, targeted the eligible bachelor, flirting outrageously, breaking up marriages, moving her dalliances from the drawing room to the bedroom. Osgood was easily snared, and they married in 1891. Irene contented herself pursuing a literary career,

and her husband's company, created solely to print her work, published her pulpy poetry. Irene enjoyed her husband's wealth and indulged her preference for wild nightlife. When the couple attended the grand opening of the Hotel Colorado in 1893, a drunken Irene was so rowdy and obnoxious that the manager asked her to leave. John Osgood was infuriated and swore revenge.

Then, Irene decided to spend some time in England, rarely crossing the Atlantic to return home. Her first novel, *My Wickedness*, a steamy bodice-ripper, was followed by *Shadow of Desire*. The *New York Times* rated it "as unwholesome as any we have had the bad fortune to read." *Idol of Passion* was another thinly disguised lurid tale of Irene's scandalous escapades. Osgood finally saw the light, and they divorced in 1899. Irene continued her stormy relationships and bitter divorces.

Never one to nurse a broken heart, a few months after his divorce, John Osgood brought home a second bride, the lovely Alma Regina Shelmgren, rumored to be a Swedish countess. Obviously smitten with his tall, lovely blond wife, a skilled equestrienne and a crack shot, Osgood built her a Tudor-style mansion on a hill overlooking the Crystal River. He named it Cleveholm Manor, but it soon became known as Redstone Castle.

Osgood controlled the mining camps near his coal mines, and most were primitive, with the families living in poorly built shacks. The majority of the workers were non-English-speaking immigrants, the result of a shrewd recruiting program started by company owners to bring peasants from Europe to work in the coal mines. Most had never worked in mines but jumped at the chance to move their families to America. In 1901, there were twenty-seven different languages spoken in the Colorado Fuel and Iron (CF&I) mines. Osgood's camps were closed to keep union organizers out and maintain control over the workforce. He used his political power to suppress unions and break the coal miner strikes in 1894 and 1901. In 1901, Osgood testified at a Colorado General Assembly hearing that management knew what was best for the miners, and unions were a threat to the United States.

In the summer of 1901, Osgood had a remarkable change in his attitude toward his workers. This might have been a desire to avoid further conflict, or Alma may have influenced him. He established a new sociology department within his company and appointed Dr. Corwin, a physician formerly in charge of the company hospital at Pueblo, to run the department. Corwin launched new programs in education, housing, industrial training, communication and social training. He started the

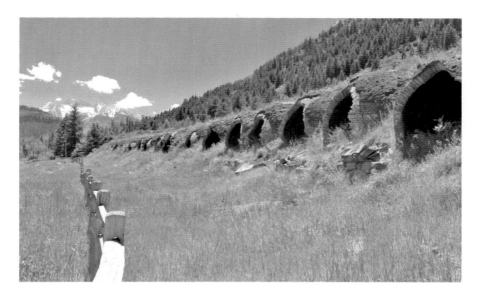

Some of these coke ovens used in Osgood's operations have been restored.

first kindergartens in the mining camps. Osgood supported Corwin's objectives and said Redstone would become the model for CF&I's twenty-eight other camps.

Osgood didn't want Redstone to be "lines of box-car houses with batten walls, painted a dreary mineral red." He wanted different styles of cottages painted pretty colors that were designed for families. He supervised the building of eighty-five cottages in the village, the Redstone Inn for bachelor lodging, the Redstone Club, the Big Horn Lodge and a library. The school offered basic educational and manual training classes and night classes in gardening and home economics for adults.

The new Redstone cottages for coke workers had shingled roofs, plastered interiors, electricity and running water. They lined a tree-shaded lane behind whitewashed board fences. Every family had a fenced yard with space for a garden, and once a month, a prize was awarded to the house with the most attractive yard. The managers' homes were set apart, were larger than the coke workers' and had indoor plumbing. Water for the village came from a reservoir. Osgood built a company store where miners spent their money or scrip for groceries and supplies. The workers had a herd of cows that were taken to the hills daily to graze and driven home at night. Each employee's family was expected to milk their cow daily and take care of it, ensuring

plenty of fresh milk for the village children. Osgood began his program of welfare capitalism of improved housing and education, hoping it would eliminate the workers' need for unions while improving the company image. This program theorized that satisfied workers are more productive and won't strike.

The Redstone Club was a handsome stone building on a hill near the village and was the fanciest clubhouse in the CF&I system. It had a large lounge with a billiard and poolroom, a library with plenty of books and weekly newspapers in three different languages: English, Italian and Slavonic. It was furnished with Stickley furniture, and soft drinks, cocoa and sandwiches were available at cost. There were showers and baths so the men could clean up after working around the sooty coke ovens before going home to their families.

The club contained a theater lit by electricity and had fine curtains and hand-painted scenery backdrops. The bar was well stocked, and rules were posted in three languages. There was one mandatory rule that everyone was expected to follow in Redstone: everyone bought his own drinks. No one could buy drinks for the house or for anyone else. Drunkenness and swearing were frowned upon.

Bachelor coke workers lived in the twenty-room Redstone Inn, and the Big Horn Lodge had luxurious apartments for visiting guests and dignitaries. It had a bowling alley and was used for banquets and business meetings. When the smoke from the coke ovens was blowing toward the lodge, guests rushed to the Redstone Inn for some breathable air.

Alma Osgood took a keen interest in the miners and their families, often riding through Redstone in her buggy. She'd stop to chat with the wives and was always interested in the children. She saw that their all their needs were taken care of and, knowing the importance of music, organized a brass band. She purchased uniforms, musical instruments, hired a music director and arranged music lessons. Because of Alma's kindness, everyone called her "Lady Bountiful."

Every December, Alma organized a lavish Christmas party for the village, which was the highlight of the winter. The children were encouraged to write to Santa Claus, and all the letters were delivered to her. Then she went to New York to purchase gifts for each of the town's four hundred inhabitants. When Alma returned, a huge Christmas tree was set up in the Redstone Club for everyone to decorate at the holiday party. Redstone was a showplace that the *Denver Post* nicknamed "The Ruby of the Rockies," while glowing reports portrayed Osgood as a benevolent executive. His social betterment work was producing grateful, contented employees.

When Colorado Fuel and Iron grew into Colorado's largest business, Osgood had to defend it against a takeover attempt by John Gates, the "Barb Wire King." People in Colorado unanimously supported Osgood's efforts in his fight with "the buccaneers of Wall Street." When he won that battle, the victory was celebrated by the miners, and Osgood became the "Lion of Redstone" in the newspapers. However, his company was financially depleted by the battle, and Osgood was forced to borrow $2 million from George Jay Gould and John Rockefeller. This opened the way to their takeover of CF&I in June 1903, forcing John Osgood out.

Osgood wasn't beaten because he still controlled the Victor-American Fuel Company, which operated coal mines in southern Colorado. Through hard work, he regained power, becoming the second-ranking coal producer in the state, competing with his own former company, CF&I. Deciding that industrial paternalism did not guarantee happy, loyal workers, Osgood didn't introduce his social improvement program in any Victor-American Fuel Company camps.

The glory of Redstone was short-lived. When the Sherman Silver Purchase Act was repealed, there was little need for coke to smelt silver ore, so the operation and the coal mines were shut down in 1909. Between 1910 and 1924, the village was deserted as the townspeople left to find jobs. Even the village patriarch, John Osgood, left his beloved Cleveholm in 1911. His personal kingdom collapsed when he and Lady Bountiful divorced around 1919.

In 1920, Osgood, now in his seventies, married Lucille Reid, who was barely twenty-five, and they returned to Redstone. Osgood was in failing health and died in 1926 at Cleveholm, leaving his estate, all his properties and business interests to his wife. Lucille promptly burned all her husband's papers, records, documents and letters, making it difficult to determine facts about his life and labor management policies. His ashes were scattered around the home he loved.

Through the years, Osgood struggled mightily with the United Mine Workers of America, and history shows that he played a role in the Ludlow Massacre and the Colorado Coalfield War. His philosophies are represented by the paternalism and kindness of Redstone contrasting with the bare-knuckled intimidation of Ludlow.

The Big Horn Lodge, the school, the Red Stone Club and many cottages are gone, but Cleveholm, Redstone Inn and the village are now protected within the Redstone Historic District.

Redstone Inn

The Redstone Inn is a Tudor-style, two-story lodge of hand-cut sandstone and frame, with a tall clock tower and its original on-time Seth Thomas clock. Its twenty rooms for the bachelor coke workers were furnished with oak Stickley furniture. There was electricity and running water, a comfortable parlor and a well-lit reading room. Meals were served in the spacious dining room, and the bachelors were expected to clean up and wear fresh clothes for dinner. Traveling salesmen, visitors and businessmen joined the bachelors when they traveled through Redstone.

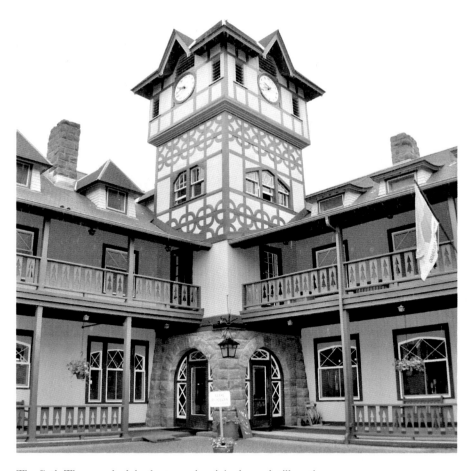

The Seth Thomas clock in the tower is original—and still on time.

When coal mining and the coke operation stopped in 1909, the lodge was closed, and despite the efforts of a tiny maintenance crew, it slowly deteriorated. Five years after Osgood's death in 1926, Lucille remarried and reopened the lodge as Redstone Inn and Resort. This was a tough time for resorts, as the Depression put a damper on tourist travel. The enterprise failed, and Lucille sold Cleveholm, the Redstone Inn and numerous village buildings and moved to the West Coast.

After World War II, there was a small amount of coal mining and coking done around Redstone, and tourist travel slowly picked up. People came to explore the lovely valley and fish in the Crystal River. To accommodate visitors, the bachelor lodge was renovated and reopened with a new west wing and first-floor patio rooms. In 1983, the capacity was increased to thirty-five guest rooms, and a restaurant and cocktail lounge were added. Many of the rooms at the Redstone Inn are furnished with original oak Stickley pieces and sleek Arts and Crafts furniture, popular in the early days of the twentieth century. The inn was added to the National Register of Historic Places in March 1980, and it is part of the Redstone National Historic District.

Ghosts

The staff of the inn has named its friendly ghost George, and he makes his home in the attic. Employees and guests have heard furniture being moved about and toilets flushing when a room is known to be empty. When they peek in the room, no one's there. Occasionally, the sound of music drifts down from the attic, and once in a while, light footsteps are heard overhead. George is only glimpsed now and then, and he's generally a quiet, peaceful spirit.

It wasn't always that way. When an employee closed the bar at night, he followed a routine, making sure all the lights were turned off before securely locking the door. Yet the next morning, the day-shift employees always found the place a mess, with tipped over bar stools and broken liquor bottles. There was plenty of finger pointing between the shifts until a thorough investigation proved that no one was responsible. George was the culprit.

Why was he upset? Did he want an after-hours drink? When he closed for the night, the bartender began leaving an open bottle of beer on the bar before he locked up and went home. Although the bottle was there, still full, in the morning, the nighttime disturbances stopped. When a Ute Indian

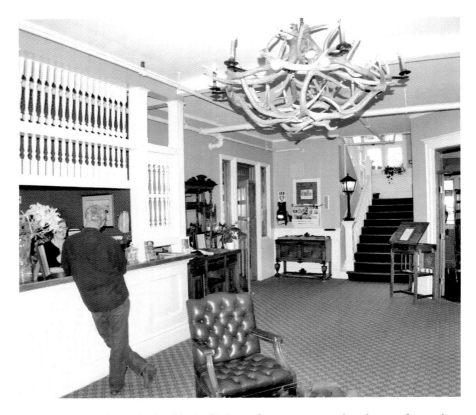

Bachelor coke workers who lived in the Redstone Inn were expected to clean up for meals.

visited the inn, he heard about this nightly routine and asked the spirit to stop expecting a beer. Whatever he said worked, no more beer was left out, and there's been no more trouble with George.

One day in 2005, a guest called and told the manager about her experience while staying in the Osgood Suite with her husband. She was awakened during the night by a whispering in her ear, and thinking it was her husband, she turned toward him. She was surprised to see he was sound asleep. She finally got back to sleep but was awakened two more times. Each time, she thought her husband was doing the whispering, and each time, he was asleep. She couldn't understand what was being whispered but insisted, "I know that something was there—whispering in my ear. I could feel the breath on my ear. I just can't stop thinking about it."

One winter night in 2007, Katie, a longtime employee, was working the night shift alone. She'd just finished her rounds and returned to the lobby,

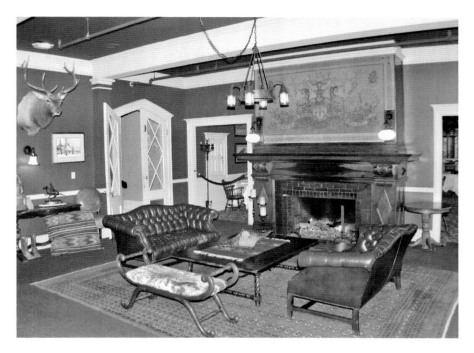

The bachelors enjoyed comfortable quarters, a reading room and meals at the inn.

where she was really startled to see a young man in a Civil War uniform. He was standing quietly by the door, and his body looked solid and real, not wispy. His longish blond hair was sticking out of his cap. Katie said he had a blank expression, and he "just stared right through me—like I wasn't there." Katie said she wasn't really frightened until he vanished right in front of her eyes.

During that same winter, one night, the only guests at the inn were a couple who had a second-floor room. The next morning, they asked the desk clerk about the noisy party on the third floor and said that it had kept them awake. They described loud music, a lot of people talking and laughing and said they could even hear children's voices. Then, to make things worse, those youngsters came down to the second floor and bounced their balls right outside their door. When the desk clerk reminded them that they'd been the only guests in the building, she got a skeptical glare. She added that the night security officer and desk clerk had been working but hadn't heard any noises. After the couple left, she remarked, "I don't think they believed a word I said."

4
ASPEN

"I never worked so hard in my life—to get rich without working!" a disillusioned prospector grumbled. He was one of many who hadn't struck it rich in Leadville and headed west, hoping to change his luck. In the summer of 1879, prospectors crossed twelve-thousand-foot-high Independence Pass, reaching the Roaring Fork Valley, where they spotted outcroppings of silver. After staking claims on Aspen, Shadow and Smuggler Mountains, they recorded their claims in Leadville, and the silver bonanza was on.

In the fall of 1879, Henry Gillespie led a group of prospectors across the mountains through deep snow to the Roaring Fork Valley. They traveled on twelve-foot-long, heavy wooden skis called "Norwegian snowshoes." They staked their claims, and a few decided to spend the winter. They named their ramshackle camp of tents and shacks at the foot of Aspen Mountain "Ute City" and signed a petition requesting a federal post office. Gillespie returned to Leadville and went on to Washington, D.C., with the petition. He met with wealthy eastern investors and organized the Roaring Fork Improvement Company to build a toll road over the mountains to Ute City.

In February 1880, a town promoter and shrewd entrepreneur, B. Clark Wheeler, and four companions set out for the Roaring Fork and scrambled over seven feet of snow, battled howling winds and frigid cold to cross Independence Pass and reach Ute City. Wheeler officially surveyed the new town, floundering around in several feet of snow as he mapped potential streets and lot boundaries. Then he scrawled "ASPEN" across his survey,

officially renaming Ute City. Next, he organized the Aspen Town and Land Company and began selling city lots for ten dollars apiece.

That winter was very difficult in Aspen because supplies ran low, and the snow piled high. Eager Leadville prospectors, too impatient to wait for the spring thaw, tried to cross Independence Pass and were lucky to reach Aspen alive. Their hands and feet were frozen, and they suffered from snow-blindness, caused by the glare of sun on the snow. Wiser men waited until spring to tackle the pass, crossing at night when the deep snow was frozen and easier to walk on.

Summer brought merchants, builders, blacksmiths, wagon masters with teams, saloonkeepers, assayers, confidence men and crooks and thieves. Aspen was a hodgepodge of tents, cabins and houses in various stages of construction, and everyone was anxious to complete building so they could start making money.

By May 1881, the legislature had named Aspen the seat of the new Pitkin County. Although isolated, Aspen quickly became respectable with a Temperance Union and plenty of law and order regulations. There was a school, churches, a literary society, a ladies' aid society and fraternal organizations. The population of both Aspen and its neighbor, Ashcroft, had swelled to two thousand each. The town's twelve saloons paid licensing fees, while the sporting women were taxed.

The building of a smelter to process the complex ore had been started, but money ran out before its completion. Then, wealthy Jerome Wheeler arrived and finished the smelter project. Married into the Macy's Department Store family, he'd already made a fortune and was buying Colorado silver and coal mines. He invested in Aspen, opening a bank, building the Wheeler Opera House and the Hotel Jerome. Surprisingly, Wheeler only came to Aspen on business trips, and his wife never even saw the town.

The smelter and ore concentrator and sampler operated around the clock, turning out bars of silver that were hauled by pack trains over Independence Pass to the railroad and shipped east. A railroad to Aspen was badly needed, and by 1886, the Denver and Rio Grande Railroad was laying track toward Glenwood Springs, and from there, tracks would run south to Aspen. At this same time, Jerome Wheeler and James Hagerman were laying track for their Colorado Midland Railroad to Leadville. From there, it would cross the Continental Divide, a difficult route that required blasting a tunnel through the mountains and building several bridges. This railroad encountered many obstacles, while the D&RG puffed into Aspen on October 27, 1887.

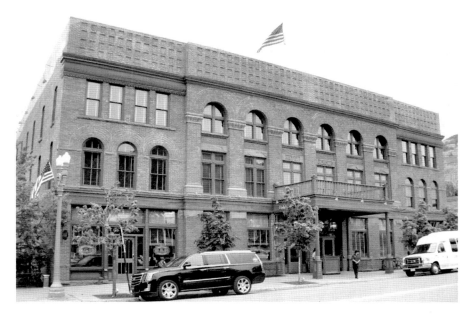

Socialites, European aristocracy and business tycoons celebrated the Hotel Jerome's gala opening on Thanksgiving eve 1889 with Colorado's Silver Kings.

There was a grand celebration on November 1, 1887, when the official D&RG train of twenty-five cars arrived in Aspen with the governor, a senator and lots of dignitaries. There were plenty of speeches, and everyone piled into carriages for a long parade past buildings decorated with flags, bunting and banners welcoming the railroad. The elegant Clarendon Hotel hosted three hundred guests at a huge banquet of oysters, green turtle soup, buffalo tongue, squab, champagne, ice cream and numerous delicacies. There were congratulatory toasts over cognac, coffee and cigars, and then everyone joined six hundred construction workers, railroad employees and town citizens at a gigantic open-air barbecue. Colorful fireworks lit up the night sky, and huge bonfires blazed on the nearby mountains.

A bit late, the Colorado Midland Railroad finally whistled into town on February 4, 1888. The two rail lines soon crisscrossed the valley to the mines, and Aspen became the major industrial and mining center between Denver and Salt Lake City. By 1889, the population had grown to twelve thousand people, who were supplied safe drinking water by the Aspen Water Company and electricity from Aspen Electric Light and Power Company. Aspen was one of Colorado's first cities to have electric power; horse-drawn

streetcars clanged from one end of town to another, and 150 homes had telephones. The community had its share of saloons and brothels, restricted to one street, but Aspen enjoyed the reputation of being one of the most family-oriented and "cultured" mining towns in Colorado. The January 19, 1889 issue of *Harper's Weekly* wrote, "Even in the early days Aspen never had much of the lawbreaking element."

Aspen's silver millionaires built their mansions on Bullion Row, and the middle-class merchants lived comfortably in spacious Victorians. The wealthy families enjoyed a lifestyle similar to other "civilized cities" with gala balls, parties and concerts, and they sent their children to eastern boarding schools. Aspen boasted over two hundred operating mines, employing three thousand men. Many were German or Irish, with plenty of "Cornish Jacks" from Cornwall, who were skilled in deep lode mining. Their working conditions were better than other mining camps because they worked eight-hour shifts for three dollars, and they were paid in cash. This gave them the freedom to shop at local stores instead of receiving scrip as pay, which had to be used at the company store, where prices were often inflated. Miners rented privately owned, five-room clapboard houses for about twenty-five dollars a month instead of shabby cottages or shacks built by the mining company.

By 1893, Aspen's mines were shipping four thousand tons of ore per week, producing nearly $10 million in silver, one-sixth of the silver mined in the United States. Then, the bottom fell out of silver mining when the Sherman Silver Purchase Act was repealed. Most silver mines closed, and miners were laid off. Unemployment spread to the smelters, coal mines and local businesses. By 1894, 80 percent of Aspen's businessmen were bankrupt, and many families had left town.

By 1897, the price of silver was cut in half, but there was still a market for it with lead, zinc, copper and gold. About 350 miners kept their jobs by accepting reduced wages. During these hard times, the Smuggler Mine produced a 2,350-pound silver nugget—the size of a small car. It was 96 percent pure silver and had to be broken up so the elevator in the mineshaft could haul it to the surface. Another large nugget weighing 1,840 pounds was found at the Molly Gibson Mine. Then, the mines flooded, and the cost of installing pumps exceeded the mining profits.

The period from 1894 to around 1936 is called Aspen's "Quiet Years." There were about five thousand diehards still living in the area in 1935, when there was growing interest in another Aspen natural resource: snow. Excited by the geography of the mountains with their long, sweeping slopes

and untouched powder, a group of locals, investors and European engineers and skiers formed the Highland Bavarian Ski Club. They began work on a lodge near Ashcroft and, in 1937, constructed Aspen's first ski lift, called a boat tow. This consisted of two sleds (boats) carrying ten passengers each that were pulled up the mountain on old mine tram cables. The boat tow was powered by an aged Model A Ford gasoline engine, and passengers paid ten cents per ride. That same year, the Roaring Fork Winter Sports Club, later renamed the Aspen Ski Club, cleared Aspen's first ski run, Roch Run, named for its designer, Swiss mountaineer Andre Roch.

The 1941 attack on Pearl Harbor halted the new ski enterprise. The Tenth Mountain Division Ski Troops, stationed at Camp Hale, trained on the slopes around Aspen, and the town became a favorite of the soldiers. When the war ended, many Ski Troops veterans returned to Colorado to develop the ski slopes and resorts. Their plans were given a boost by millionaire tycoon Walter Paepcke, who attracted wealthy investors to form the Aspen Ski Corporation in 1945. Aspen was on its way to becoming a world-class ski resort.

Paepcke organized the Aspen Institute and Aspen Music Festival, creating the town's reputation as a cultural center. There was phenomenal growth between 1960 and the end of the century. Aspen's population increased more than 500 percent, from 1,101 in 1960 to 6,222 in 1998. As skiing became the rage, everyone headed for the slopes, and John Denver's songs about "Rocky Mountain High" publicized Colorado and drew more tourists. The dirt roads were paved, and high-end boutiques and gourmet restaurants replaced small, independent shops. Aspen became a chic, glitzy retreat for celebrities—musicians, artists, writers and movie stars were joined by politicians and corporate executives. Mega-mansions were built, and Aspen became the nation's most expensive real estate market. Today, it struggles with the problems created by its own popularity.

Hotel Jerome

The Hotel Jerome opened on Thanksgiving eve 1889 with a grand ball the likes of which had never been seen in Aspen. New York socialites mingled with beef barons from Chicago, European aristocracy and the Silver Kings, those newly rich millionaires from Colorado. The gentlemen wore top hats and tails, while the ladies were lovely in shimmering gowns and sparkling

diamonds. After a fabulous midnight banquet, the two hundred guests danced the night away.

The hotel cost $160,000 to build, about $1.6 million in today's dollars. The three-story brick structure was one of the first hotels west of the Mississippi to be fully lit by electricity. It had hot and cold running water, steam heat and even an elevator operated by hand-pulled ropes. There were ninety sleeping rooms, and fifteen had their own private bathrooms. The luxurious hotel sparkled with opulent wall coverings and lush draperies, crystal chandeliers, massive diamond dust mirrors, marble floors, gleaming oak panels and fine furnishings.

Fresh vegetables were raised in the large greenhouse, and a Parisian chef presided over the preparation of gourmet meals. Violins played as guests feasted on squab, oysters, champagne, truffles and the finest delicacies. After dinner, they relaxed around the parlor's marble fireplace or enjoyed Chopin played on the grand piano in the rotunda. The gentlemen adjourned to the billiard room or enjoyed cigars and brandy at the hand-carved golden oak bar. The ladies lounged in the library or chatted with friends in the private reception room.

The atrium lobby is an eclectic blend of historic artifacts, original western art and sleek modern style.

In 1892, Wheeler sold the hotel to a Denver businessman before the repeal of the Sherman Silver Purchase Act ended Colorado's silver boom. This wasn't a good time to own a luxury hotel, and when taxes weren't paid, Pitkin County seized it, turning the hotel into a boardinghouse.

In 1910, a traveling salesman, Mansor Elisha, bought the hotel from the county. Many of Aspen's once-wealthy citizens lived there because it was less expensive than maintaining their large Victorian mansions, which they couldn't sell. The room rates of ten dollars a month included meals. The fifty-cent fried chicken dinners were very popular, and everyone came on Sunday afternoons for free musical performances by local singers and musicians. The J-Bar survived Prohibition by transforming itself into a soda fountain, occasionally serving something stronger than a cherry fizz. The local favorite was the Aspen Crud, a vanilla milkshake liberally laced with bourbon.

In 1935, Laurence Elisha took over the hotel when his father died. The soldiers of the Tenth Mountain Division were favored guests and, when on leave, enjoyed a hotel room and a thick steak for just one dollar. The Ski Troops often ended grueling cross-country training exercises by skiing to the hotel entrance, where they were welcomed with free drinks.

When World War II ended, Walter Paepcke, a wealthy industrialist and philanthropist, leased the hotel and hired Austrian architect Herbert Bayer to renovate it. Bayer painted the warm red brick exterior a light gray with blue window arches, a change that was quite unpopular with longtime residents. The plumbing was updated, the kitchen was modernized and antiques from Chicago's Palmer House spruced up the parlors and guest rooms. Fine Swiss cuisine was served in the dining room, and the best liquors were dispensed at the bar.

A swimming pool was added, which became a popular gathering place for luminaries, who were drawn to the Aspen Institute's seminars. Its diverse speakers stayed at the Jerome, and there were many thought-provoking poolside philosophical discussions. During the 1940s, Hollywood discovered Colorado, and the Hotel Jerome became a favorite of Lana Turner, Claudette Colbert, Ray Milland, Dan Dailey, Robert Stack, John Wayne, Hedy LaMarr and Gary Cooper. Movie stars mingled with Pulitzer Prize winners and prospectors, while an opera singer chatted with a boxer and a ballet dancer. When avid skier Lowell Thomas heard about Aspen's new slopes, he became one of the town's most enthusiastic supporters and often broadcast his radio program from the hotel.

After Paepcke died in April 1960, the Jerome declined and was eventually closed for several years. In 1968, it was again sold for back

Gonzo journalist Hunter Thompson held court in the Jerome's J-Bar nearby, a comfortable spot where locals mingled with celebrities.

taxes, and rooms rented for five dollars a night. Hippies camping out in the woods often sneaked in the back door to grab a furtive shower on the third floor. During the '70s, a party was usually in full swing at the hotel, and the J-Bar's stools were filled by ski bums, working cowboys and young college kids. Gonzo journalist Hunter Thompson always started his day by picking up his mail at the post office and then taking his special spot at the end of the J-Bar. He'd order breakfast, lunch and dinner all at the same time and held court here, drinking, eating and watching TV news and sports and then drinking some more. If people wanted to meet Hunter, they'd come to the Jerome. The crowd at the bar often included Jack Nicholson, Jimmy Buffett, Bill Murray and members of the Eagles band.

About 1985, Aspen real estate magnate Dick Butera purchased the Jerome and began a $10 million renovation. He updated wiring, heating and plumbing and had layers of paint peeled off the exterior to reveal its terra-cotta brick and the sandstone masonry. The number of rooms was

The Ski Troops of the Tenth Mountain Division were favored guests, enjoying a steak dinner and room for one dollar.

reduced to twenty-three, including six suites. The interior was restored to the Eastlake/Gothic style or "Mining Camp Victorian" that was popular in the 1880s and '90s. Many of the original expensive fixtures were polished and reinstalled, and the guest rooms were furnished with fine antiques, restoring the hotel's opulence. Old photos were helpful in the restoration of the J-Bar, with its polished tin ceiling and ornate oak bar. When completed, all it needed was a few dusty cowboys and grizzled miners to take it back to 1889. In 2002, a $6 million project added a new rear wing and a grand ballroom.

Now an Auberge Resort, the hotel has ninety-three spacious rooms and has been recognized by Travel Advisor as one of the "Top 10 Hotels in the World" and as a "Leading Hotel of the World." The Hotel Jerome was listed on the National Register of Historic Places in 1986.

Haunted Hotels of Northern Colorado

Ghosts

The Jerome has always been the center of Aspen's social life, from the opulent boom days through the hard times. Once again, it's an elegant resort in a world of glitz and glamour, but spirits of its past remain, attached for eternity.

The ghost of a little boy who drowned in the hotel's swimming pool around 1935 haunts the halls. He's seen most often around room 310, which is directly over the pool. A woman staying in this room called the front desk to report seeing a little boy who was wet and shivering and seemed lost. When the general manager came upstairs to investigate, the child had vanished, leaving nothing but wet footprints. The guest register was checked, but there were no children staying at the hotel. Over the years, this child has been encountered in the hallway, shivering and holding his towel. When he's approached or spoken to, he vanishes, leaving behind small, wet footprints.

A travel writer, Chris Faust, had a scary experience when she and a friend stayed at the hotel in a room above the pool. They went to dinner, and when they returned, the heat had been turned on, and the bathroom sink was full of soapy water. Neither had used the sink before going out, and the guest soaps were still in their wrappers. Both were certain the heat had been turned off. Chris wrote about her stay at the hotel, mentioning this strange incident and was surprised to receive an e-mail from a reader who'd had a similar experience. She wonders—who's the spooky entity turning up the heat and taking a sponge bath in guest rooms?

The hotel has another ghostly resident, Katie Kerrigan, a pretty Irish chambermaid, hired when the hotel opened in 1892. Katie was popular with the other employees and had several admirers, but there were a few jealous maids who played tricks on her. One cold, wintry night, a maid told Katie that her pet kitten had gotten out and fallen in a nearby pond.

Katie rushed out to look for her pet, ventured out too far on the pond's thin ice and fell through. A passerby pulled the girl from the frigid water and rushed her to the doctor, but she developed a terrible case of pneumonia. Despite the best care, Katie died, but she never left the Jerome. Sometimes she helps the maids with their work and turns down bedcovers in guest rooms in the evening.

Henry O'Callister has never checked out of the hotel either. He'd been prospecting in the mountains around Aspen but was discouraged and down on his luck when a fortunate turn of his shovel unearthed a 1,500-pound silver nugget. Henry had struck it rich! The newly wealthy miner moved

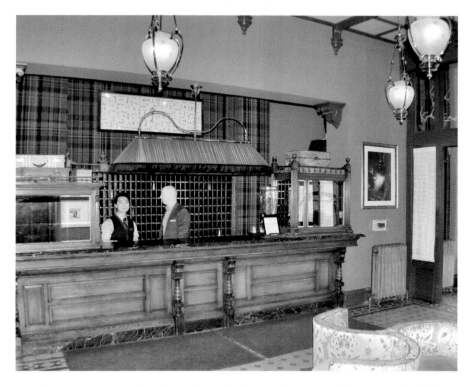

A cowboy greets guests when they arrive at the Jerome, the center of Aspen's social life since the boom days.

into the Hotel Jerome, where he met Clarissa Wellington, who'd just arrived from Boston. The young couple fell in love, but Clarissa's father wouldn't give them permission to marry. Clarissa went home to attempt to change her father's mind, and he refused to allow her to return to Colorado. Henry languished at the hotel, waiting and rushing to the depot every time the train pulled in, but Clarissa never came. He ran out of money and returned to prospecting, but he didn't make another lucky strike. Henry died penniless, probably of a broken heart, and his sad spirit wanders the Jerome's halls, waiting for his lost love.

5
LEADVILLE

"Boys, I've got all of California in this here pan!" yelled the prospector as he swirled the gold pan full of small nuggets and gold dust. This veteran of the California Gold Rush knew he'd struck it rich this frigid day in 1860. Within a few weeks, there was a conglomeration of rough log cabins, tents, huts and brush shelters in the gulch. The first saloon was an open shack with a board plank thrown over two barrels. The prospectors called the California Gulch camp "Oro City," Spanish for "gold." By mid-summer 1860, there were five thousand gold seekers staking claims up and down the gulch, and the gold rush was on.

Augusta Tabor, the wife of Horace "H.A.W." Tabor, the first woman in camp, opened a store and began serving meals and selling homemade bread and baked goods. The miners were so impressed with Augusta's cooking—a vast improvement on their usual fare of beans and black coffee—that they built a log cabin for her, expanding their dining room.

During the first year, $1 million in gold, $91 million in today's dollars, was found in California Gulch, and by the end of the Civil War, it had produced $5 million. When the placer deposits were exhausted, the population dwindled to about five hundred souls. The few who hung on cursed the heavy black sand that clogged the riffles in their sluice boxes and filled their gold pans with waste. Winter at ten thousand feet was bitterly cold, and some inventive prospectors used the pesky black stuff to fill the cracks and chinks between the logs in their cabins. It worked just fine and kept the icy winds out.

In 1876, when this black sand was finally assayed, everyone was dumbfounded because the cursed stuff was lead carbonate, full of silver ore. The news spread like wildfire, and a silver boom was on. Once again, hopefuls swarmed over the area, digging holes, hoping to find riches by the bucketful. Most had no knowledge of geology and didn't recognize the grayish black, silver-rich rocks when they stumbled over them.

Getting to Leadville was difficult because there were no railroads, and trails over the high mountain passes were dangerous, open only after the deep snows melted. At ten thousand feet altitude, this didn't happen until May or June, when long mule trains, loaded with heavy mining machinery and equipment, began the struggle through the mud and snow. This slow-moving traffic plagued stage drivers, who bogged down in muck, causing their passengers to get out and walk. Wealthy dandies slogged along with hopefuls who couldn't afford stage fare. They trudged over treacherous thirteen-thousand-foot-high Mosquito Pass with huge packs on their backs. Everyone was in a hurry because the trail would be impassable once the snows started again in late summer.

The new silver camp was dubbed Leadville, and its main street, a rough dirt track, was a crawling mass of horses, wagons, mules and men. Eddie Foy, the vaudeville entertainer, played Leadville, saying, "The place was a tangle of human beings on foot carrying furniture, bedding, window frames, tools, picks and shovels, everything imaginable."

Shelter was at a premium and the mammoth boardinghouse tents advertised sleeping space for five hundred men, but the owners usually crammed in three hundred more. Beds and blankets were rented for eight hours, and when your time was up, someone took your place. Leadville thrummed with activity around the clock, sawmills buzzed and the sound of hammering was a constant racket. The noise kept many awake despite their exhaustion, and there was a popular joke that people left town to get some sleep.

It was a common practice in mining camps to "grubstake" prospectors with food and mining supplies in return for a share of the profits if they struck it rich. In the spring of 1878, Horace Tabor grubstaked two German prospectors who found a massive lode of silver and filed a claim, listing Tabor as one-third owner. They named the mine the Little Pittsburg, and owning it was the next best thing to having a license to print money. One acre of ground produced almost $2 million the first year. Tabor bought them out and began picking up other claims, becoming wealthy overnight. Within a year, H.A.W. Tabor was one of the richest men in Colorado, a

Champion Mine and Mill near Leadville produced gold and silver from the 1890s through 1919.

silver king who made so much money that he couldn't spend it as fast as it rolled in. By the end of 1879, his holdings were capitalized at $20 million, about $350 million in today's dollars. Like many others, he moved his family to Denver.

Leadville boasted 120 saloons, and the competition for customers was fierce. The saloons offered brass bands, snake charmers, magicians, shooting competitions and dancing. State Street, the heart of the red-light district, was lined with cribs and brothels with over two hundred prostitutes. Some were only twelve or thirteen years old, and many were orphans or runaways. Tiger Alley and Stillborn Alley, flanking State Street, crawled with every form of corruption, and the abandoned bodies of unwanted babies gave the dismal place its name.

The more expensive ladies of the evening worked their way off State Street into the fancy houses scattered throughout Leadville. They had regular clientele among the town's distinguished citizens, and the community tolerated these bawdy houses. Since prostitution was illegal, it couldn't be taxed, so the police devised an ingenious system that paid their salaries.

Every madam paid a monthly fifteen-dollar fine, which the police collected, and then the madam charged her "boarders" five dollars apiece.

The scent of money brought all types of criminals: robbers, thieves, thugs and footpads—all eager to grab their share of the wealth. Claim jumping became common, and in town, lot jumping was a problem. Lots sold for thousands of dollars, only to be grabbed by toughs.

There was such an epidemic of holdups that many didn't venture out after dark for fear of being thumped over the head, robbed and left in the gutter. Winters were harsh, and as freezing winds and icy blizzards rattled the town, frozen corpses and murder victims turned up in the back alleys. The attacks continued, and the townspeople grew desperate, hiring a sheriff and eight deputies and organizing a merchant patrol.

After another robbery in November 1879, the two culprits were caught and lodged in the partially completed jail. An irate vigilante committee broke into the jail, outfitted the criminals with hemp neckties and strung them up. They pinned a notice on one body warning that the "Vigilantes' Committee meant business," with a list of targeted criminals.

The grand opening of Leadville's opera house was marred by the hangings; the house was only half full as a troupe of performers kept the audience of four hundred howling with laughter, but the elegant opera house earned the raves. Horace Tabor had spared no expense, and the furnishings were quite grand, with hand-painted stage curtains, red plush seats and the latest in theater lighting. A massive coal furnace kept theatergoers warm, and the Tabor Opera House was heralded as the best between St. Louis and San Francisco.

On July 22, 1880, the first train, run by the Denver and Rio Grande Railroad, chugged into Leadville, carrying General and Mrs. Grant and a large entourage. They received a thunderous welcome from five brass bands, the volunteer fire companies, mounted police, two cavalry units, five companies of infantry, thirty Civil War veterans and a one-hundred-gun salute. Grant gave a rousing speech and then visited the mines.

The train's arrival signaled the beginning of a sustained economic boom. More people, supplies and mining equipment were delivered, and tons of bullion ore were shipped out. The train brought actors to the opera house, and John Philip Sousa's band rocked the rafters with its stirring marches. British playwright and poet Oscar Wilde, quite the dandy in his diamonds, velvet suit and silk cape, gave a scholarly lecture about art to a packed house. Then, H.A.W. Tabor and a crowd of local officials escorted the poet to the Matchless Mine, where they were lowered in buckets down to a new tunnel

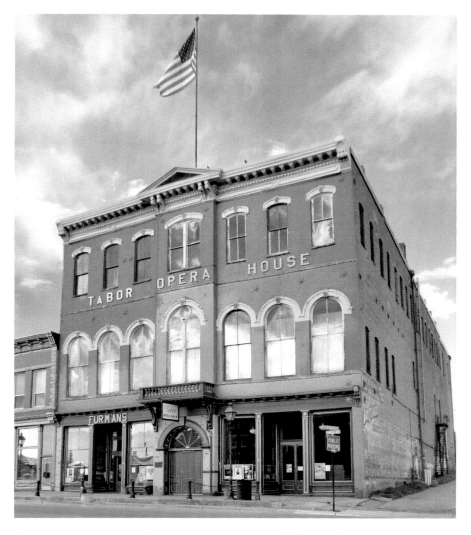

The elegant Tabor Opera House opened in November 1879. John Philip Sousa's band, Sarah Bernhardt, Oscar Wilde and many celebrities performed on its stage.

named "Oscar." A fine banquet was served by candlelight in the tunnel before Wilde toured the Matchless and chatted with the miners, finally leaving to catch the 4:30 a.m. train.

Sooner or later, everybody came to Leadville in the 1880s. Among the more notorious were Jesse and Frank James, the Daltons, Tom Horn, Bat Masterson and con man Soapy Smith. Doc Holliday and Wyatt Earp arrived

in 1882 after the gunfight at Tombstone's OK Corral. Wyatt moved on, but Doc stayed, dealing faro and playing poker at a saloon; he also shot his last man here. Five years of piercing cold and Leadville's thin air worsened his tuberculosis, so the emaciated gambler headed for Glenwood Springs.

Leadville passed quickly from a wild camp into a town with fine residential districts, schools and churches, and five newspapers cranked out the headlines for residents who could read. Marshall Field used his silver profits to start the Chicago department store; David Moffat became a railroading giant; a Jewish immigrant, Meyer Guggenheim, and his seven sons purchased two defunct silver mines and found a bonanza, which became the foundation of the Guggenheim fortune. David May opened a clothing store and grew rich selling the rugged pants made by Levi Strauss of San Francisco. May was stiff competition for the dry goods store of B. Daniels, partners Mr. Fisher and Mr. Smith, and they eventually merged into May D&F Company.

H.A.W. Tabor became hopelessly infatuated with a beautiful blond divorcee, "Baby Doe" McCourt, and abandoned Augusta—his thrifty, hardworking wife of many years—to take up with her. Their love affair scandalized society, and they married in 1883 in Washington, D.C., with only President Arthur and seven of the invited guests attending. The love-struck Horace showered his stunning young bride with a $75,000 diamond necklace, fine jewelry, expensive gowns and furs. Baby Doe rode about Denver in a $3,000 gilded coach, pulled by four horses in gold harnesses, and gloried in her plush private box in Denver's elegant Tabor Opera House.

In 1893, Horace Tabor's financial empire collapsed, and at age sixty-five, the free-spending former millionaire was reduced to shoveling slag for three dollars a day. Then he was appointed Denver's postmaster in 1898, and just when things were looking up, he developed acute appendicitis and died in April 1899. Tabor's body lay in state in the capitol building, and thousands came to pay their respects. Baby Doe, now a penniless widow, returned to Leadville, making her home in a drafty shed at Tabor's Matchless Mine. She lived in poverty for thirty-five years, refusing charity, and after an especially severe snowstorm in March 1935, Baby Doe was found dead, frozen on the cabin floor. She was buried next to Horace in Denver.

By the late 1890s, Leadville's population had dropped to around twelve thousand, and the colorful, free-spending days were gone. In pursuit of tourist dollars in the winter of 1895, the town staged a Crystal Carnival, featuring a huge "Palace of Ice" containing a fifteen-thousand-square-foot

ice-skating rink, a ballroom and a café, all lit by sparkling arc lights. Leadville welcomed trainloads of excited visitors, but the weather warmed early, and the Ice Palace slowly melted away—along with the town's hopes.

Gold had been ignored in the search for silver, and J.J. Brown, a miner who'd worked his way up to superintendent, devised a way to extract gold ore from the Little Johnny Mine while preventing cave-ins. This vein of gold was so wide and so pure that it was heralded as the world's richest gold strike. By 1893, the Little Johnny was producing 135 tons of gold ore a day, and J.J. was given mine stock by the grateful owners. J.J. and his wife, Maggie, became fabulously wealthy and moved into a Denver mansion. Maggie's bravery when the *Titanic* sunk in 1912 made her a heroine, whose story became the Broadway play *The Unsinkable Mollie Brown*.

During Prohibition, bootlegging became Leadville's big business, with stills hidden in old mines and boarded-up buildings. It supplied much of the state's illegal hooch, and with twenty-six saloons masquerading as soft drink parlors, it was a good place to drink and gamble. It was legal to purchase alcohol for medicinal purposes if the patient obtained a permit at Leadville's Lake County courthouse, and everyone joked that this was Colorado's sickest county.

The Depression brought hard times, and suicides mounted as men couldn't find work to feed their families. By 1932, the city treasury was empty, and Leadville couldn't pay its bills. During World War II, the army built three ski runs on Cooper Hill where the soldiers of the Tenth Mountain Division learned to handle their long heavy skis. After the war, this became Ski Cooper, a small family-friendly ski area.

Delaware Hotel

Fortunes were made in Leadville, and they didn't all come from treasure found in the earth. For the Callaway brothers, successful Denver merchants, wealth came from a hotel they built on Harrison Avenue. They christened it the Delaware, after their home state, and launched this enterprise in October 1886.

The elegant three-story brick building had fifty guest rooms with gas lights, hot and cold running water, steam heat and fine furnishings. Some rooms had water closets, and there were three bathrooms on the second and third floors for the other guests. After the hotel was launched, George and

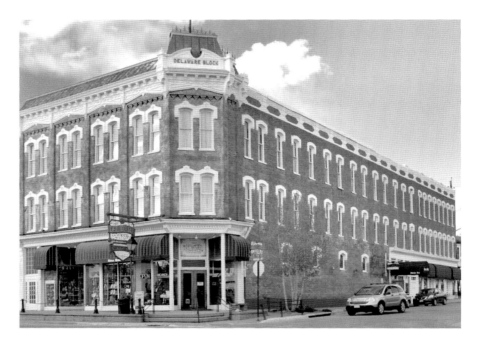

The Delaware Hotel, opened in 1886, was occasionally visited by Doc Holliday, a faro dealer in a nearby saloon.

William retuned to Denver, while John remained to guide the hotel through the next twenty years.

During the depression of 1893, Callaway kept the Delaware open by lowering rates for traveling salesmen and reducing rent for first-floor merchants. He was popular with Leadville citizens and hotel employees and was described as a "delightful man who wore Ben Franklin glasses, a derby and a suit with a vest." John loved classical music and often played the operas sung by Enrico Caruso on the newly invented phonograph.

Baby Doe Tabor, the widow of H.A.W. Tabor, her silver millions gone, was always welcome at the Delaware. She wrote letters, made her notes and enjoyed a cup of tea at a desk kept just for her use. During winter, her feet and legs were wrapped in gunnysacks for warmth when she walked to town from her wooden shack at the Matchless Mine.

In 1946, the Callaway heirs sold the hotel, and it changed hands again in the 1980s. The owners received a grant from the Colorado Preservation Commission to help with a $1 million renovation of the historic building. The Delaware is included in the seventy-square-block Leadville National

Historic District, and spending a night here is like spending a night in an antique store or museum. The spacious Victorian lobby has elegant armoires, fancy settees, colorful Tiffany lamps and sparkling crystal chandeliers. There are exquisite walnut and cherry antiques and museum-quality vintage pieces, all tastefully arranged. The upstairs halls are lined with more period pieces and cabinets with glass fronts displaying 1890s gowns and accessories. If a guest falls in love with his brass bed or an antique, he can buy it, and the hotel will ship it home.

Ghosts

The "lady in white" is a tragic spirit thought to be Mary Coffey, who died here. Mary's troubles began when she married Jerry Coffey, a bad-tempered lout who couldn't keep a job. They traveled around the West as he looked for work. Their marriage was not a happy one, as he was jealous and often flew into vitriolic rages. The couple came to Leadville with their four children in 1889, and trouble began shortly after.

The second-floor stairs where the "lady in white" sometimes wanders.

Room 13 where poor Mary Coffey was fatally shot by her husband in 1889.

One night, Jerry attacked Mary with a candlestick; tore her dress off, shredding it; and chased her from the house. Mary was terrified and had her husband arrested. Local newspapers reported that he was soon released. Three months later, Mary was assaulted again, and when the police tried

to arrest him, Coffey fired several shots at the officers. This time, he faced attempted murder charges. There are gaps in the records, and by November 1889, Coffey was not in jail but was residing at the Delaware Hotel in room 13 with Mary and the children.

One evening, Mary left their room to check on an ill female friend also staying at the hotel. When she returned, Jerry grabbed her by the throat and, waving his pistol around, accused her of cheating. Terrified, Mary somehow got out of his clutches and ran toward the door. Jerry shot her in the back, and when she fell, he shot her again and then stepped over her bloody body and left the room. Guests, who'd heard the shots and screams, threw open their doors to see Coffey rushing down the hall toward the stairs.

He was quickly captured by the sheriff and admitted to shooting his wife because "she harassed the life out of me!" Mortally wounded and paralyzed by two bullets that shattered her spine, Mary whispered to the sheriff, "Jerry was crazy from jealousy." She lingered for two days, and her children, who'd witnessed the ugly scene, were at her side when she died on November 6. Mary was buried in the Leadville cemetery, and the children were taken in by her friends. Jerry Coffey was found guilty of second-degree murder and sentenced to Territorial Prison.

The lady in white, believed to be Mary, is seen from the waist up, floating along the halls. A wispy woman in a long, white dress has been glimpsed near the second-floor stairs. A teen, staying at the hotel with his father, encountered her when they returned from dinner and were walking up the stairs. The lady in a white dress came down the steps, looked directly at them and vanished. Later, they saw this same woman entering one of the hotel rooms.

Roger Pretti—an expert on Leadville's citizens who persist in remaining with the living even after they've died—wrote about the spirit of Coffey in his book *Lost Between Heaven and Leadville*. About two o'clock on a June morning in 2011, the desk clerk received a call: "This is Mary Coffey, and I'll be checking out at 7 o'clock." She asked for her bill, but the clerk couldn't prepare it because there was no one by that name registered. The call originated from room 2, which was vacant. When the desk clerk told the manager about the incident, he was stunned to learn that Mary Coffey had been murdered at this hotel 122 years earlier.

During a recent renovation, a painter working in the upstairs hall was startled by a sudden blast of frigid air rushing past him. He looked around for an open window but saw none and continued working. Then,

The night clerk's job at this front desk is not for the faint-hearted.

a second blast of cold air surrounded him. Frightened and sure that something strange was going on, he decided that he'd done enough for the day and left.

When two members of Spirit Bear Paranormal stayed in room 11 at the Delaware, their EMF meter went crazy, flashing and beeping during the night. The second time the meter sounded its alarm, they heard the floor creaking loudly as if someone was approaching their bed.

Hotel employees say things are moved about or disappear, and doors open and close when no one's there. The lights flick on and off by themselves, and cold drafts are suddenly felt in strange places. Disembodied voices have been heard coming from vacant rooms on the second floor. One housekeeper said she's uneasy when she must clean a guest room alone, and she frequently peeks into the closet and makes sure the hall door is closed. A feeling of being watched is common around the Delaware, especially at the front desk. The night desk clerk's job is especially spooky, and one clerk insisted, "Sometimes, I know someone is with me, and I'm not alone!" Reluctant to mention "ghost," several employees remarked quietly, "There's something here." Another interrupted emphatically, "I know this place is haunted!"

6
FAIRPLAY

"Grab-all!" That's what disgruntled prospectors called the diggings along Tarryall Creek in South Park in 1859. The lucky ones who'd found gold staked their claims on every bit of promising land along the creek and refused to subdivide their holdings with late-comers. These "turn-aways" headed farther west and found gold in the South Platte, naming their new camp Fairplay, promising fair treatment for all. Then, a wide vein of gold was found in the mountains, and this camp was called Buckskin Joe, after a mulatto prospector. More gold was discovered at Montgomery, at the base of a fourteen-thousand-foot peak near Hoosier Pass. Talk of the looming war dominated conversation as Southern sympathizers headed home to join the Confederacy.

Jim and John Reynolds, Southern prospectors, schemed about grabbing gold to support the Confederacy. They fantasized about plundering the Denver Mint, but robbing stages and travelers in the wide-open spaces of South Park was a better plan.

In July 1864, the Reynolds gang stuck up the stage from Buckskin Joe, grabbing a sizeable amount of gold, currency and checks, and they even took driver Ab Williamson's last fifteen cents. Robberies of stages, travelers and even ranches increased as the gang ranged across South Park. There was so much trouble that all stage travel from Denver to South Park and Leadville was stopped. Posses were rounded up, and finally, the gang was tracked to Hall Valley northeast of Kenosha Pass. The outlaws were surprised, one was killed and the rest of the gang, including John Reynolds, scattered and escaped.

The following week, another posse captured five outlaws, including Jim Reynolds, hauled them to Denver and turned them over to the local militia because of their allegiance to the Confederacy. Shortly after, Reynolds and four others were put in chains and loaded into a wagon driven by Ab Williamson, the stage driver who'd lost his fifteen cents to the outlaws. Guarded by a company of the Third Colorado Calvary, they were headed to Fort Lyon for a military trial.

The prisoners never arrived at the fort. Months later, the skeletons of four men in chains were found tied to trees, each standing in his boots. There was a bullet hole in each skull. Everyone agreed this was part of the Reynolds gang, but what happened to the fifth prisoner? Was it Jim Reynolds? Did he make it to New Mexico, rumored to be his brother John's hide-out? A few years passed, and John Reynolds was shot stealing horses. Knowing the end was near, he drew a map showing where his gang had hidden their loot. For years, treasure hunters have tromped through the canyons around Kenosha Pass, clutching maps and compasses, but the stash of gold and cash has never been found.

Fairplay became the Park County seat in 1867, and within a year, it had sixty buildings, three hundred inhabitants and stages arriving weekly from Denver, Colorado Springs and the San Luis Valley. Rich silver strikes were made high on the peaks, and Alma was established at 10,500 feet altitude. A large smelter that could handle the complex ores—separating the gold and silver from the copper, iron or lead—was built, and Wells Fargo Express made regular shipments of gold and silver.

By 1873, businesses were thriving along Fairplay's Front Street, with a blacksmith, several hotels, saloons, shops and restaurants. On September 26, a fire started in the wood-burning stove at the Fairplay House Hotel, and within minutes, the second story was engulfed in flames. Fire swept quickly through the business district of wooden frame buildings. There was no fire department and no way to bring sufficient water from the river to quench the flames. Buildings in the path of the flames couldn't be dynamited because there wasn't enough blasting powder in town to do the job. The dynamite was up at the mines in the mountains. The fierce wind blew sparks into homes half a mile away, setting them on fire. The business district was reduced to piles of smoldering ashes, and much of the town was gone. The Denver newspapers carried the story and asked for donations to help the people of Fairplay, who had no shelter at almost ten thousand feet with winter coming. Rebuilding began the following spring, and a new red stone courthouse rose from the ashes.

The first one-man mining operations required little capital, but as placer deposits declined, larger sums were needed to find and process the gold, so prospectors borrowed money. If they weren't able to repay their loans, their claims fell into the hands of banks and investors, who sold them to the large mining companies. Two Fairplay bankers acquired one thousand acres and four miles of land containing numerous placer claims and decided to try hydraulic mining. This requires a lot of unskilled labor, so they brought in two hundred Chinese workers. They built flumes and ditches to carry water from the river and washed the gold from the hillsides with powerful streams of water.

The Chinese built their camp on the south bank of the Platte River with twenty small, one-room cabins in a row, some with a common wall. Each cabin had a peaked roof with a door and window in front and a vegetable garden and chickens in back. The men reported to the tong house every morning to get their work assignments. A few were cooks and housekeepers, while Chinese women, like Big Mary, opened a laundry, and Little Mary sold radishes and lettuce from her garden. Many Fairplay residents purchased fresh water from a Chinese man who carried it in coal oil cans suspended from a yoke across his shoulders. Direct from the river, it was cleaner than the muddy ditch water running through town.

The Asians endured the usual bigotry from Fairplay's citizens who complained that the "Celestials" worked for lower wages. When the hydraulic operations slowed, some worked in the coal mines nearby that supplied the railroad. Unlike California, where Chinese miners prospected and laid track for the Union Pacific Railroad, the Fairplay and Gilpin mining districts were the only places in Colorado where they were employed.

The Denver, South Park and Pacific Railroad laid its narrow-gauge tracks from Denver to Como, arriving in 1879, and an auxiliary line was laid to Fairplay. The wide-open spaces of South Park continued to attract drifters, thugs and criminals, and there were brazen robberies of travelers, freighters and stages. One freighter was held up by three crooks in plain sight of other wagons on the road. The law made little attempt to chase down the robbers, and a person who ventured on the road was expected to defend himself. The rule of the day became "Shoot on sight!" It didn't take long for settlers to become believers in vigilante justice—eager to pass judgment and dole out punishment without the benefit of the lax legal system. The Fairplay courts were very unpopular because of the high number of ridiculously light sentences judges handed down. Criminals who were unquestionably guilty were acquitted, and many murderers were sentenced to only eight years in the Territorial Prison.

Trouble began on April 1, 1879, when Thomas Bennett was cleaning debris from the town's water ditch near the Fairplay House. He stopped work, and while he took a break in the hotel, the ditch overflowed, sending water toward John Hoover's house. Rushing into the hotel, the furious Hoover screamed at Bennett and shot him in the chest. The victim was carried to a hotel room and died before the doctor arrived. Bennett was well liked, and Fairplay's citizens were furious with Hoover, who was mean, nasty and often drunk. He was arrested by the sheriff and taken to Denver, where he was held for over a year awaiting trial.

In April 1880, Hoover was returned to Fairplay, where Judge Thomas Bowen found him guilty of manslaughter, not murder, and sentenced him to only eight years in the penitentiary. The citizens were infuriated. The next morning, an angry mob of masked men woke the sheriff, demanding the keys to the courthouse jail. When he refused, the mob broke into the jail and hauled Hoover from his cell. They marched him upstairs to the second floor, placed a noose around his neck and shoved him out the window. When the sheriff arrived, he found his prisoner dangling from the courthouse window, dead. The mob had dispersed, and no one ever identified any of the members. The next day, when Judge Bowen came into his courtroom, he found a coiled rope lying on his desk. Ignoring the rest of the cases for trial, the judge and the district attorney immediately left town, and both resigned a few days later.

Shortly after, the newspaper, the *Flume*, carried a bold warning: "Citizens, our laws are a farce! Our district Attorney bought!…Beware of the Vigilantes!" It promised swift punishment for criminals. Less than a year later, Park County's first public execution, the hanging of a murderer in the town ballpark, drew throngs.

By 1883, Fairplay's population had grown to eight hundred, and it had a smelter, plenty of stores, saloons, a new bank and a two-story, stone schoolhouse. Mining continued until the Sherman Silver Purchase Act was repealed in 1893, closing the silver mines.

Fairplay declined until the 1920s, when the gold dredge arrived to tear up the area's creeks. Its sharp-toothed bucket took huge bites of river sand and gravel and tossed giant boulders about, eventually sifting out the gold. The destruction ended when gold mining was stopped by World War II, but the dredge resumed operations after the war and was actively unearthing gold until 1952.

During the 1950s, Fairplay's citizens became concerned that the old mining camps in South Park were being destroyed by time, weather and

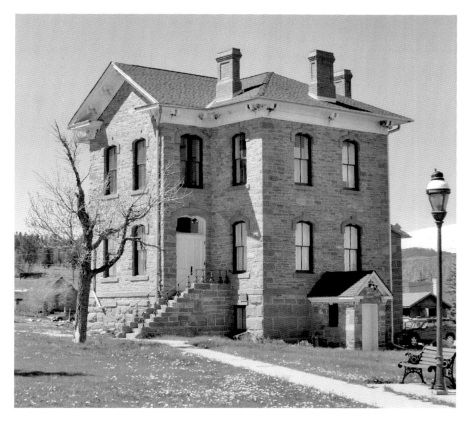

Park County Courthouse, where vigilantes hanged a murderer from the second-story window above the front door in April 1880.

vandals. They began re-creating an 1800s gold mining town and brought historic buildings from Buckskin Joe, Alma and camps high in the Mosquito Range. Set up around the old stone brewery and saloon on Front Street, the weathered frame structures make up South Park City.

One of Fairplay's most popular summer attractions is Burro Days, and there's plenty of competition. A contest quaintly known as "Get Your Ass Up the Pass" requires fully loaded burros and their two-legged companions to race fifteen miles up the mountain to 13,188-foot-high Mosquito Pass. Once on top, the pair turns around and dashes back down. Rules are strict for the human team member. "There's no riding! The runner may push, pull, drag or carry the burro, but the human contestant shall at no time progress except under his own power."

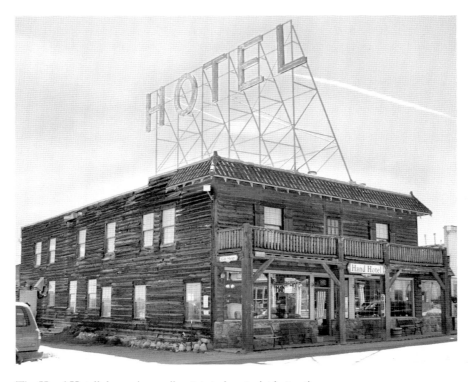

The Hand Hotel's large sign easily attracted motorists' attention.

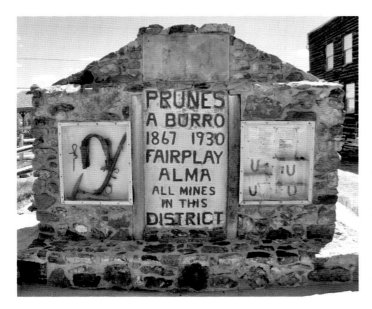

The monument to Prunes, a faithful burro who spent his life working hard in the mines and mountains and was a loyal friend.

The races are chaotic, with shouts, whistles and loud brays as contestants wheedle and coax their stubborn four-legged partners to move. One fast burro made it up the mountain and back down in record time, but then he planted his hooves in the dirt and refused to cross the finish line. He even let the stragglers race past him and his frustrated partner.

Fairplay honored its favorite burro, Prunes, with a large stone monument on Front Street. A veteran of the mines, Prunes had pulled plenty of ore cars and carried heavy equipment over narrow mountain trails. He joined prospector Rupert Sherwood as he searched for that lucky strike. Rupert often sent the burro to town with his grocery list, and after the merchant packed the goods on his back, Prunes made his rounds of local businesses and homes for his favorite treats of biscuits and pancakes. The faithful burro always returned to Rupert's camp. After many years, Rupert gave up prospecting and turned Prunes loose. The little donkey remained in Fairplay, where he was a big favorite of the children and continued his rounds for treats until he died in 1930. Prunes was buried on Front Street, and Rupert, who still lived in town, said he'd like to be buried near his faithful partner. When the old prospector died, his ashes were placed near Prunes's monument.

Hand Hotel

Jake and Jessie Hand built the Hand Hotel in 1931, and it was easy to spot because of the large sign on the roof. Automobile travel was increasing, and the Hands wanted to attract people passing by on Highway 285. Business was good, and folks came to hike, explore old mining towns and enjoy Jessie's Rocky Mountain trout and fresh apple pie. Affectionately known as Grandma Hand, she was an expert fisherwoman and often took her guests out to catch their dinner in nearby streams.

The Hands operated the hotel for several years but eventually sold, and after several ownership changes, it closed. In 1987, it was purchased by Pat Pocius, who took on the big job of remodeling and bringing the hotel up to current standards. When it reopened, its rustic exterior and cozy log cabin interior, with its "Western Victorian" furnishings, was in tune with Fairplay's early days. Its eleven guest rooms were named for colorful Colorado characters. The China Mary Room recalls the Chinese woman who operated a laundry here in the 1880s. It has black lacquered furniture and is decorated with an Asian flair. The Mattie Silks Room, with its red

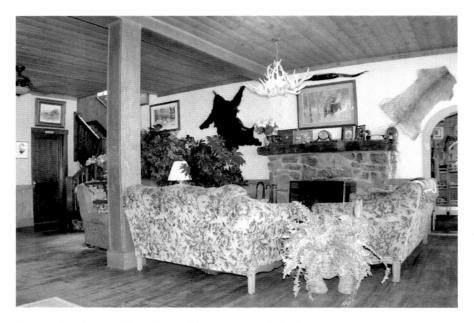

Guests relaxed in the Hand Hotel lobby after a day of fishing.

flock wallpaper and lush décor, would have pleased Denver's most notorious madam. Grandma Hand's room, room 12, has hand-stitched quilts and her favorite rocking chair, and her photograph hangs on the wall.

Ghosts

Pat soon noticed that the hotel had some unusual guests. She was chatting in the kitchen with a friend when an antique pie safe slid off a shelf and crashed to the floor as if moved by invisible hands. The hotel cook complained about problems with the stove, and one day, its burners refused to stay lit. This was a modern stove with individual knob controls for each burner, and there had been no difficulty with the gas line. No one was near the stove except the cook, who was busy with lunch orders. When the stove was moved, the repairman discovered the floor underneath had burned completely through down to the supporting joists. After the floor was repaired, the stove worked perfectly. Pat said the hotel's protective spirit, called Ben, was on the job.

Ben's been seen by many employees—a full-body apparition that appears when he's needed. A new employee who didn't know about Ben said a

male worker had helped her open a door when the key became stuck in the lock. Then he went about his tasks, pushing a linen cart down the hall. She described Ben, but at the time, there were no male employees, and the hotel did not use linen carts.

Pat spent her first winter in the hotel and described it as "really scary." She said, "I hired a night manager as soon as I could." She believes the hotel is haunted and recalls several frightening paranormal occurrences that convinced her some spirits have remained. For many years, employees disliked going to the basement, saying they were uncomfortable and even got a "queasy stomach." Occasionally, a frightful growling came from the basement's dark shadows.

Pat decided to sponsor a Halloween haunted house for Fairplay's children and hired a carpenter to build it in the basement. He brought his young son to the job, and work was going well when the child suddenly started crying, yelling, "Don't puppy, get away! Don't bite me!" The carpenter rushed to his terrified son and saw a wound on his hand. The doctor was called, and the injury, pronounced a possible bite, was treated. The police searched the basement but found nothing.

Old-timers believe a dog's spirit lives in the cellar, but the creature has been seen in the hotel, too. One guest was awakened as her bedcovers were pulled off by a large, dark dog. When she yelled, the dog snarled and simply disappeared. Another time, the police chief dropped by the hotel, and before he left, he went to the men's room. Suddenly, he dashed out, holding up his britches and yelling, "There's a vicious dog in there!" A check turned up nothing.

In 2010, a well-known paranormal investigator, Chuck Zukowski, brought his crew to spend the night and check the activity throughout the hotel. Concerned about safety and the unusual paranormal incidents, he divided the team into groups of three. They were equipped with full-spectrum night vision digital video recorder (DVR) cameras, EMF meters and a KII meter, which detects sudden spikes in electromagnetic readings. Paranormal investigators have used this to communicate with ghosts. They had sophisticated temperature meters, full-spectrum digital cameras, EVP voice recorders and infrared lights. The investigators set up their equipment in the basement and three guest rooms. There were no other guests that night. Chuck was interested in the basement dog and the stories about a Denver madam. Reportedly, she brought her soiled doves to the hotel one summer to entertain Fairplay gents. There were rumors that a doctor performed abortions for some girls and buried the fetuses in the

Grandma Hand loved her rocking chair and still makes a fuss if it's moved.

hotel basement. Chuck said, "We got scared plenty of times that night but always went back for more." While the investigators were in the basement, they said, "The responses we got through our Q&A sessions using the EMF meter were just outstanding!" One man felt something brush against his leg several times, and it even touched him. Another developed a burning

sensation on his lower back that felt like a bad sunburn. The group's investigation was cut short when one woman became very nauseated, and red marks appeared on her skin.

Occasionally, guests complain about the noise from a party overhead on the third floor. This is strange because the hotel has only two floors. Guests and employees have been frightened by shadowy figures, and some have caught a glimpse of a woman's face in mirrors in several different rooms. A little girl has been seen near the stairs—when there are no children registered. Housekeepers have complained that newly made beds are rumpled or a small impression has been left in the spread, as if someone has laid down.

There's always been a lot of paranormal activity in Grandma Hand's room since she's keeping an eye on her hotel. An older woman has been glimpsed at the window of her room, and her favorite fragrance of roses is often evident. Grandma's empty rocking chair moves slowly back and forth when no one's near. In 2002, the *Denver Post* carried a story about one guest who was kept awake as the chair squeaked and rocked. Finally, he jumped out of bed and dragged it into a nearby vacant room. Returning to bed, he couldn't sleep and even imagined he heard an angry voice demanding, "Where's my rocker?" He finally got up and brought the rocker back into the room and slept peacefully the rest of the night.

After the investigators on Chuck Zukowski's team returned to their homes, one man named Daniel was awakened by a disturbing dream in which an older woman told him that he had taken something of hers. Hopping out of bed to check his pockets, he found a room key. Was this just a coincidence or did Grandma Hand send a reminder? The key was mailed back—no one wants to be on Grandma's bad side! The group's findings are available at www.ufonut.com. Chuck commented, "This particular investigation had plenty of surprises, and I guarantee there's something going on at the Hand Hotel."

Fairplay Grand Historic Hotel

Louis Valiton built his hotel on Main Street in 1873, when Fairplay was rebuilding after a disastrous fire earlier that year. It could accommodate one hundred guests and had a dining room, a kitchen and two parlors, one for ladies and one for gents. The hotel changed hands and names several times until 1921, when a fire that started in the kitchen stove destroyed the

Julia watches over the Fairplay Grand Historic Hotel, where she worked long ago. *Amanda Williams.*

frame building. Owner Agnes Slater immediately began rebuilding a rustic Adirondack-style hotel on the old building's foundation. The grand opening was a gala chamber of commerce banquet and dance in June 1922. The hotel's large parlor and dining room were ideal for community meetings and dinner dances, and it became the center of Fairplay's social activities. Agnes advertised her hotel in numerous travel and tourism magazines, and its indoor plumbing, with hot and cold running water, and steam heat were attractive features. The rooms, some with private baths, rented for four dollars a day.

In 1934, the sun porch was converted into the Silverheels Lounge, with a handmade mahogany bar dating to around 1883. It had been abandoned in Rachel's Place in Alma for years after the saloon closed. That old deteriorating building joined the collection of vintage structures in South Park City, and this fine saloon piece, with its elegant mirrored backbar, was the highlight of the Silverheels Lounge.

During World War II, the hotel was closed, but it reopened after the victories in 1946 and featured shows by comedians Jerry Colona and Bob Hope. In the decades following, the hotel's fortunes fluctuated with the economy, and sometimes the restaurant and bar brought in more business than its rented rooms.

The hotel closed in 2008 and was sold in 2010 to Constance Shoppe, who renovated it and changed the name to the Fairplay Valiton Hotel. Julia's Place, the dining room, became the Middle Fork Restaurant. In

The original wooden floors creak and groan, welcoming visitors to the Fairplay Grand Historic Hotel. *Amanda Williams.*

August 2014, it was sold to Lorna Arnold, and once again the name changed to the Fairplay Grand Historic Hotel. Drinks are served to locals and visitors in the River Roxx Lounge, and lunch is served in Gatsby's. The hotel earned a spot on the National Register of Historic Places in 2008.

Ghosts

Despite the numerous changes, Julia still watches over this old hotel, where she began working as a young woman a long time ago. The creaky floors of the lobby announce the arrival of guests and visitors, and many think those squeaks announce Julia's presence, too. Julia takes a special interest in the kitchen and dining room. Waitresses who've worked there said that Julia was always checking on them, and she occasionally rearranged table settings. Strange things happened in the kitchen, especially early in the morning when the cook was trying to prep food for the day. "I always feel like she's lookin' over my shoulder!" she commented. Julia

This stair landing is Julia's favorite spot to watch others working, just as she did years ago. *Amanda Williams.*

lived upstairs in room 205 and often observed the hotel staff at work from a spot on the staircase.

There are cold spots scattered throughout the hotel, doors open and then slam shut loudly and sudden drafts cast a chill. Julia was dedicated to keeping the hotel and restaurant running smoothly, but she had a fun-loving side, too. She loved to dance and was quite popular with the gents of Fairplay. A pretty woman, she always had plenty of partners to twirl her around the floor at the hotel's annual Harvest Ball. What happened to Julia? No one's sure if she found someone special, married and settled down. Who knows, but many believe her story did not end well. Occasionally, there's a melancholy feeling within these old walls, but then music drifts through the hotel and floors creak and groan as Julia and her beaus spin about, dancing once again at the Harvest Ball.

7
EVERGREEN

When Thomas Bergen saw Elk Park in 1859, he exclaimed, "This is the most beautiful spot my eyes have ever rested upon!" Surrounded by thick forests of pine and spruce with snowy peaks on the horizon, Bergen gave up his dreams of glittering gold to make his home here.

He'd joined a wagon train headed for Colorado during the Pikes Peak Gold Rush, and when he reached Cherry Creek, he immediately turned west into the mountains. He enlisted the help of the ten young men who'd come with him from Illinois. They cut down trees and built a sturdy log cabin. By the Fourth of July 1859, his cabin was completed, and Bergen had become acquainted with the Utes and Sioux camped nearby, whose summer hunting grounds he'd invaded. He headed home to sell his farm, collect his wife and daughters and bring them west.

The Bergen family lived in their cabin until 1865, when they built a larger one with space for overnight travelers. When gold was discovered in California Gulch near today's Leadville, another rush was on as thousands of hopeful prospectors headed over the mountains. Many stopped at Bergen's, where they could get a meal and a bed for one dollar a night. He built a flourishing business swapping footsore oxen with fresh ones that had been reconditioned on his fine pastureland. Bergen grew potatoes, vegetables for his family and grain and hay for the stock.

Some gold seekers decided to stay on at Bergen Park, as it was called. There was plenty of grazing and farmland, wood for cabins and abundant water. The magnificent trees were so thick in places that clearing had to

be done before a man on horseback could ride through. A few miles south of Bergen Park were lush meadows and many springs along a stream they named Blue Creek.

Amos Post, a huge, heavy man with a full dark beard, one of Bergen's "ten young men," married his eldest daughter. A skilled carpenter, Post built a general store nearby and went into business. In 1877, seeing better trading opportunities a few miles south in a little logging settlement in Bear Creek Canyon, Post moved his store there. About forty people lived here, but there were six lumber mills on Upper Bear Creek. Lumbering became big business, and timbers were sold for use in the mines, to build houses and for railroad ties. Charcoal was in great demand for the new ore smelters, and wood was converted into this fuel. Logs were hauled by wagon teams down the Bear Creek Canyon to the little town of Morrison and loaded on the train to Denver. Lumber was even bartered: one thousand board feet could buy eleven dollars worth of groceries.

The James Gang visited Colorado Territory after its failed bank robbery in Northfield, Minnesota, in 1876. One old-timer remembered the gang hiding out near North Turkey Creek, a few miles south of Bergen Park. The outlaws had a vacation here, living on wild game and trout that were so plentiful that they caught the fish with their hands. Bathing must not have been in their plans, as people who caught a glimpse of the outlaws said they looked "like demons," their faces covered with soot and whiskers. The gang eventually moved on to Georgetown, where the men stocked up on supplies. They had plenty of money and spent freely, often paying for $5 worth of groceries with $20 gold pieces and not bothering with the change. Once the James Gang rode on, there were plenty of rumors floating around that it had buried $50,000 in a mountainous area that's now Brook Forest. Years later, Jessie James's nephew showed up with a map that his uncle had given him. He spent three years combing the region but said he never found the hidden money.

For many years, the settlement along Bear Creek was known simply as "The Post" until D.P. Wilmot arrived and bought a large tract of land. He was so pleased with his huge evergreen trees that he began calling the area "Evergreen." Gradually, others picked up the name, and Evergreen was even listed in the Colorado Business Directory. By 1886, the population was two hundred, and there'd been no trouble with the Utes, who'd remained friendly and often camped near homesteads. Occasionally, they'd warn a settler who was building too close to tiny streams that could quickly become

raging torrents. Many wives said that the Utes always smelled freshly baked bread and came around on baking day. Everyone knew their fondness for sugar, and once a homesteader's wife gave them this treat, the Indians left.

Ranchers raised hay in the small meadows for winter feed for their cattle. Some hauled their hay to Idaho Springs, where they sold it to the mines to feed the mules and burros that hauled ore wagons and pulled ore carts inside the mines. The mining camps became eager markets for the settlers' vegetables and potatoes, milk, eggs and butter.

The Evans Ranch, a large cattle ranch at the foot of the peak named for the territorial governor, was purchased in 1868. The governor's family spent the summers there, as the cooler mountains were a refuge from the heat of the plains. Some of these early stage stops and lodging places became Evergreen's first summer retreats.

By 1890, Evergreen was a summer resort with cottages, cabins and summer homes. There was plenty of camping, horseback riding and fishing in the streams. Visitors would make the frightening trip up rugged Bear Creek Canyon in buggies and wagons and on horseback. With the advent of the auto, travel became easier, and the road up the canyon was improved in 1911.

One of the first resorts, Troutdale, began in 1890 as a cluster of cabins that grew into an elegant four-story hotel with 140 rooms, a dining room seating 250, a lounge and the Rainbow Ballroom. Troutdale's limousines met eastern guests who'd arrived on the train at Denver's Union Station and then caught the connecting line to the Morrison Station. Next came the hair-raising ride up Bear Creek Canyon. Troutdale had a swimming pool, golf course, billiards and even a barbershop and pharmacy. The guest register soon contained the signatures of Teddy Roosevelt, Greta Garbo, Clark Gable, Douglas Fairbanks Sr., the Marx Brothers, Mary Pickford, Franklin D. Roosevelt and hundreds of other notables. The dance floor extended out over Troutdale's small lake and was enclosed in glass. Guests danced in the moonlight to the big-band sounds of Tommy Dorsey, Paul Whiteman, Artie Shaw and Benny Goodman. This glamorous watering hole became the center of the social life of Evergreen's summer population.

As more lodges, resorts and guest ranches opened and transportation improved, there was a steady increase in the number of "summer people." They came in late May when the grass turned green and the aspen leaves and early wildflowers emerged. People joked that Evergreen had five hundred residents in the winter and five thousand in the summer. Social activities increased, and resorts like Brook Forest, Troutdale and Greystone Guest Ranch buzzed with activity. Still, Evergreen remained a summer resort; the

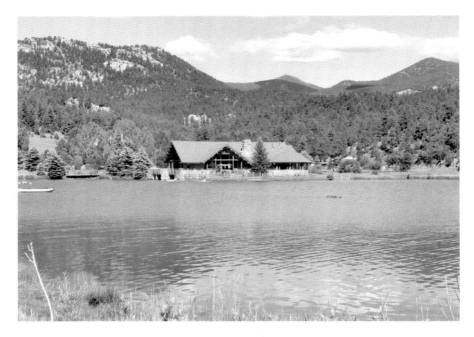

Evergreen Lake, built for flood control, is the community's favorite spot for fishing, boating and ice skating.

first nippy days brought an exodus, and the small community shrank to its usual size.

A dam was built in 1927 for flood control on Bear Creek, creating Evergreen Lake. For years, residents had talked about building a dam, fearing another flood like the one in 1896. Raging waters had surged down the canyon to Morrison, sweeping away homes, destroying everything in their path and killing twenty-one people. The lake filled to capacity with the spring runoff in 1928.

Evergreen Lake has been well loved and well used through the years. Liberally stocked with trout, summer brings many anglers, and in winter, the frozen lake is peppered with persistent ice fisherman. Children build special memories of ice skating and fierce hockey games here. In the summertime, the lake is dotted with canoes, small sailboats, paddleboats and rafts. Since the 1950s, many have decided that Evergreen would be a wonderful year-round home, and the population has grown to around nine thousand. Many residents commute to their jobs "down the hill" in Denver.

Brook Forest Inn

The Brook Forest Inn has been the center of a small summer community southwest of Evergreen since the early 1900s. The Westerfield family filed a homestead claim on 350 acres in 1909 and built a log cabin near Cub Creek. They planted vegetables and worked the land for about two years but became discouraged by the deep snows and harsh weather, which froze their crops. They abandoned their homestead in 1911.

Austrian Edwin Welz and his Swiss wife, Riggi, had come to Colorado in 1910 and were working at the Brown Palace. They saw an opportunity in the growing resort hotel business, and in 1913, they learned about the abandoned homestead near Evergreen. After a rugged trip up a narrow, twisted trail, they found the forlorn cabin with a board sign nailed to it bearing the faded words "Brook Forest." The Welzes liked the mountainous area, which reminded them of Switzerland, and they decided this would be their home.

They filed a homestead claim, repaired the cabin, added a small building and planted a vegetable garden. Knowing their dream of a resort hotel wouldn't come true if the guests couldn't reach it, they started work on the wagon trail. Impassable in the winter, it followed the creek and was so steep, twisting and narrow that a horse and buggy couldn't even turn around. They began blasting rocks and widening it so Edwin could commute to Denver for work and haul building materials from Evergreen. For years, he continued to work in Denver, traveling up and down Brook Forest Road to earn money for "their mountain project."

Finally, the Welzes had saved enough money to hire an architect to draw plans for their Swiss chalet, but they were unable to obtain financing to start building. So they began building themselves, laying the foundation and hiring carpenters when they could afford them. They built with large logs and white and rose quartz and worked on the structure as time and money allowed. They incorporated the original cabin into the parlor and lounge, and the interior had massive, weathered beams. There were multi-paned windows and several rock fireplaces. The red roof was steeply pitched, and a second-story balcony completed the Tudor Revival/Swiss Chalet–style building. The inn had all the luxuries of the day: indoor plumbing with full baths, hot and cold running water and electricity.

In 1919, the Welzes entertained their first guests, two schoolteachers from Denver. The ladies enjoyed the landscaped grounds with the sundial, fountains and old-fashioned lights illuminating the garden paths. The couple continued to improve the inn, adding nine chalet cottages, a swimming pool,

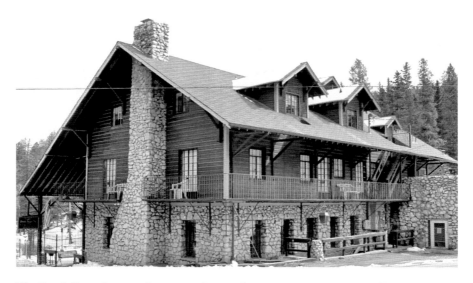

The Brook Forest Inn was the center of a popular summer resort area near Evergreen.

a spacious recreation hall and a stable for their riding horses. By 1935, they'd built a huge outdoor barbecue oven to handle meals for large groups that held their picnics and social events at Brook Forest. Then, "Maw and Paw Welz" expanded their dining room to accommodate the numerous fans of Riggi's cooking.

Edwin led guests on horseback rides to Mount Evans, while other guests enjoyed afternoons on the double tennis courts or playing lawn croquet and games of horseshoes. Hikers found plenty of interesting trails crossing the resort's 350 acres.

Evenings were relaxing times around the fireplace and full of stories. A favorite was the tale about the James Gang, which had hidden its loot somewhere around Brook Forest.

During the 1930s, the German American Bund was organized by Americans of German ancestry whose goal was to promote support for the Nazi cause. When a group of German bicyclists stayed at the inn, Evergreen was full of rumors. Nationally, sentiment turned against the bund, and the groups dissolved. The bicycling Germans moved on, too, but rumors persisted that they'd been raising money to support the Nazi cause. Supposedly, they'd stashed the cash somewhere around the Brook Forest Inn.

Edwin Welz died in 1946, and Riggi sold her little piece of Switzerland. Brook Forest continued to operate until 2000, when it was sold. The inn was

turned into a computer training center, which failed, and the inn reverted to its previous owners. In 2010, Jon and Melissa Barton purchased the inn, and after a renovation, it's open for overnight guests, dining, weddings and special events. The Brook Forest Inn was listed on the National Register of Historic Places in 2009, and it's included on the Colorado State Register of Historic Properties.

Ghosts

The Brook Forest Inn pops up when locals tell ghost stories because there have been so many strange happenings here. The unusual experiences of employees and guests are hard to ignore, and reports of paranormal investigations are widely available on the Internet and social media. The new owners are determined to redeem the old inn's reputation for fine food and accommodations, so spirits are confined to the bar, and talk of hauntings is discouraged.

The rooms have been renamed, but whether it's the Monte Carlo or the Ambassador Room, longtime employees can tell you where the chambermaid, Jessica, was strangled by her lover, Carl, who worked in the livery stable. Carl heard a rumor that Jessica had been unfaithful to him and stormed to the inn to confront her. She was cleaning in the Monte Carlo Room on the second floor, and when Carl accused her of infidelity, they had a terrible argument. Suddenly in a rage, Carl grabbed Jessica and began choking her. When he got his temper under control, it was too late; he'd killed the poor girl. Appalled at what he'd done, Carl rushed back to the livery stable, and overcome by grief and fear, he hanged himself.

Mediums sense a mournful, sad presence upstairs and overtones of fear and violence. Paranormal experts say that sometimes when lives are cut short or ended violently, the spirit becomes "stuck" where it happened, unable to move on. Images of a woeful-looking man have been glimpsed in mirrors throughout the inn, and passersby and people living across the road have seen the apparition of a woman on the second-floor balcony.

One couple captured numerous digital pictures of orbs in the murder room and were repeatedly awakened by the bathroom door as it creaked open. Then the man saw a "weird emerald light," which lasted about ten minutes and then faded away. They heard footsteps in the hall but were too frightened to investigate. They were the only guests that night, alone after the employees locked up and went home.

A previous owner of the inn said two guests were headed downstairs for breakfast when they encountered a stranger standing in the hall. He stood there, blocking their way and didn't say a word; then he just faded away. The frightened couple rushed to tell the owner about the experience and were assured they were the only guests. When they went into the lounge, they were startled to see a picture of that same man hanging on the wall.

Riggi and Edwin Welz had one son, born on June 11, 1911. When he was ten years old, the boy became ill with pneumonia, and despite the doctor's efforts, he died on March 25, 1922. A wispy image of a child has been seen in the third-floor hall, and occasionally, children's laughter and running footsteps are heard. A little girl is occasionally glimpsed, and soft sobbing is heard. Guests often wonder if little hands have moved their toiletries about.

A father and his daughter decided to investigate the inn and set up their ghost-hunting equipment in the attic, where the Welz boy often played. Their camera batteries were immediately drained, so the father left to get replacements. He was gone just a few minutes, and when he returned, he sat down on a box. He immediately felt a slight tug on his hair and told his daughter. She said while he was gone, she'd asked any spirits to indicate their presence or make a sound. Then, inspired, she requested, "Just pull on my dad's hair." Right after the spirit complied, her father snapped a photo of a very large orb that appeared to be sitting right next to his daughter.

The stairs from the main floor to the upper level are unusually chilly, and a housekeeper said, "Things get moved around here. You can be the only person working in a room and your tools still get moved." An employee closing the inn for the night locked the doors and then heard sounds of a large party upstairs. There was loud talking and laughing, but there were no guests that night. The place was empty. Frightened, she quickly turned out the lights and left, saying, "That's one party I don't want to attend."

Five different ghosts have been detected at Brook Forest. The Rocky Mountain Paranormal Research Society working with the American Association for Critical Scientific Investigation into Claimed Hauntings spent several nights there. The members were armed with every kind of sophisticated ghost-hunting equipment: monitors, meters, thermometers, camcorders and infrared and digital cameras. Their equipment was set up throughout the inn, and the most activity and magnetic anomalies were picked up in the murder room. There were unexplained fluctuations in the meter readings, and energy repeatedly moved from the center of the room toward the southeast corner, near the balcony. The investigators concluded, "There is something unusual occurring at the Brook Forest Inn."

8
DENVER

The little camp of St. Charles on the eastern side of Cherry Creek didn't look like much in November 1858 when William Larimer, a town promoter from Kansas, arrived with a small party. Its founders had named the place and then headed home, afraid of a harsh winter. Larimer's party promptly jumped the St. Charles town site and, since this region was part of Kansas Territory, named their new town Denver City, after the territory's governor, James Denver. They organized the Denver City Land Company and laid out lots and streets, which they named after themselves. The first general store opened; it was stocked with a wagonload of Taos Lightning whiskey, which mountain man Uncle Dick Wooten had brought from Raton, New Mexico Territory. The first snowflakes fell on Denver City's seventy-eight log cabins clustered together with their residents hoping to survive the winter of 1858–59.

William Russell and a group of Georgia prospectors had set up a rival camp on the west bank of the creek. They named it Auraria after their hometown and set out to compete with Denver City. When the Pikes Peakers reached Auraria and Denver City in April 1859, instead of boomtowns, they saw scruffy camps of discouraged prospectors still hoping to make that lucky gold discovery. Not much had been found in Cherry Creek, so many turned around and headed home.

Ironically, as the disgusted "go-backers" left, an impressive amount of gold was being discovered in the mountains nearby. In May 1859, John Gregory found a rich vein of gold-bearing quartz, the first in Colorado.

When he learned this news, William Byers, founder of the *Rocky Mountain News*, visited the prospector's camp in Gregory Gulch to see the $1,800 worth of gold Gregory had found in three days.

Next, George Jackson, an experienced California Forty-niner, found rich placer deposits on Chicago Creek, near present-day Idaho Springs. It wasn't long before two thousand prospectors were scrambling through the gullies and creeks around today's Central City. William Russell and the Georgia prospectors discovered placer gold in Russell Gulch, where another camp, Nevadaville, popped up. Black Hawk, a city overnight, bustled with saloons, shops and restaurants.

Merchants and tradesmen headed west to make their fortunes by "mining the miners," and real estate speculators pushed the price of lots up as businessmen rushed to open stores, restaurants, saloons and banks. There was fierce competition between Denver City and Auraria to snare new businesses, and both wanted the newspaper. They promised free land to editor William Byers, who published the region's first newspaper, the *Rocky Mountain News*, just six days after he arrived in April 1859.

Byers's first newspaper office was above an Auraria saloon, but stray bullets from the bar below disturbed his sleeping printers. Finally, to please both sides, he moved the newspaper to neutral ground, an office built on stilts on a small island in Cherry Creek, between the two camps. This proved to be a big mistake a couple years later when Cherry Creek flooded, sweeping away the *Rocky Mountain News* buildings close to its banks. The printers narrowly escaped drowning when rescuers threw them ropes and pulled them to safety.

Vegetable gardens and hay fields planted in the rich soil of the river bottomlands supplied the mining camps. By the summer of 1860, Denver was thriving, with two daily newspapers raving about their city's rapid growth to six thousand people. Its privately operated mint turned out ten- and twenty-dollar gold pieces from prospectors' gold dust. Denver and Auraria ended their rivalry in a torchlight ceremony on the Cherry Creek Bridge, agreeing to one name, Denver.

In February 1861, the Colorado Territory was created with William Gilpin, the first territorial governor, and to the dismay of Denverites, Golden became the capital. Just six weeks later, the Civil War broke out, and many Southerners abandoned their claims and left to join the Confederacy. During the Civil War, growth was slow, and in 1863, a fire wiped out most of Denver's business district. As a result, laws were passed prohibiting the use of wood when rebuilding downtown buildings. Then,

a flash flood swept down Cherry Creek, killing twenty people and causing $1 million in damage.

Troubles with the Arapahos and Southern Cheyennes had been simmering for years as white men continued to come in endless streams from the East. Treaties were ignored, and Indian lands were seized for mining, ranches, farms and towns. There were scattered clashes between the two factions, and tensions mounted, culminating in the Sand Creek Massacre of November 24, 1864. Instead of "settling the Indian problem," this hate-motivated slaughter of about two hundred Indian women, children and old men stirred the tribes to seek revenge. Stages and wagon trains were attacked, telegraph wires cut, small settlements were burned and travelers, homesteaders and ranchers were killed. Supply trains were captured and their goods taken, leaving Denver citizens with dwindling food supplies. Union Pacific work crews were attacked as they laid track, delaying completion of the transcontinental railroad. Governor Elbert declared martial law and telegraphed Washington, begging for troops.

A Congressional investigation labeled the Sand Creek Massacre as "foul, dastardly, brutal, cowardly and…a disgrace to the uniform of the United States soldier." After three years of strife, treaty agreements were reached in 1867, removing the Cheyennes and Arapahos to reservations in Oklahoma. The Indians retained their hunting rights and often returned to Colorado, where sporadic raids and battles occurred. Peace did not come to the Territory until 1870.

Denver boosters were dismayed upon learning that Union Pacific officials had decided to avoid the rugged Rockies in favor of an easier route across Wyoming. This was a dark time for Denverites, who knew the railroad was vital to the city's future. Tradesmen deserted the Mile-High City as property values started a downward spiral. The Denver Board of Trade, the forerunner of the chamber of commerce, was quickly organized, bonds were sold and cash or labor contributions were obtained. Enough money was raised to build a connecting line to Cheyenne, where it joined the Union Pacific in June 1870. In the meantime, additional large land grants persuaded the Kansas Pacific to lay its tracks farther north toward Denver. When its first train puffed triumphantly into Denver, it was cause for celebration, as the city now had two rail outlets to the rest of the nation.

The railroads led an economic boom as freight costs for hauling heavy mining equipment, dry goods and food supplies dropped significantly. Improved mining equipment reduced the complex gold ore more efficiently, greatly increasing profits. Towns developed along the rail

lines, and farmers and ranchers had a way to get produce and cattle to eastern markets.

The discovery of silver in Leadville spurred Denver's growth, and many newly rich Silver Kings left the mining camps behind, heading for the capital city. They built mammoth mansions on Capitol Hill, spending their money as fast as it rolled in. H.A.W. Tabor built an opera house in Denver and the five-story Tabor Block of commercial buildings downtown where fine hotels such as the Windsor, the Albany and the Metropole served Denver's 200,000 business travelers. The peak of this commercial architectural splendor was the completion of Henry Brown's palatial Brown Palace Hotel, one of the nineteenth century's finest. By 1890, Denver's population had tripled from 35,000 to 106,000, and business was booming as real estate values continued to rise. The gawky camp had grown into its optimistic title, "Queen City of the Plains."

During the economic depression of 1893 marking the end of the silver boom, hordes of jobless miners and destitute families drifted into Denver, where rescue missions provided tents, bedding and food. These resources were soon exhausted, so in desperation, the men were given lumber and encouraged to build flatboats, which they'd sail on the Platte River to Nebraska, where there were jobs. This experiment failed when hundreds became stranded on sandbars in the shallow river between Denver and Nebraska.

The railroads offered cheap fares to the Missouri River, but frantic, hungry men hijacked Union Pacific trains, forcing the crews to carry them to the Nebraska border. Denver's boom was busted, and its population dropped to ninety thousand by 1895. Although the outlook was dark, a golden glimmer of hope came with the discovery of gold at Cripple Creek. Between 1900 and 1920, Colorado's mines produced almost $500,000,000 of gold, but painful experience taught civic leaders that the economy could no longer be based solely on mining.

World War I and the Depression slowed Denver's growth, but Roosevelt's New Deal renewed hope as the WPA became the state's largest employer. Its forty-three thousand workers built schools, hospitals, sewage disposal plants, dams and recreation centers. The Civilian Conservation Corps (CCC) carved out the Red Rocks Amphitheater and an open-air theater on Flagstaff Mountain, built roads in Colorado National Monument, planted nine million trees, stocked two million fish and constructed eighty-six thousand check dams on streams.

During World War II, troop trains carrying four million service personnel crowded Union Station, where Red Cross donut ladies and the moms of servicemen greeted "the boys" with donuts, coffee and

hot turkey sandwiches. Lowry Air Base and Buckley Field were built, and Fitzsimmons Hospital was refurbished. Defense dollars poured into the community, creating jobs, but few Denverites knew that lethal gases and napalm bombs were being made at the Rocky Mountain Arsenal. Ammunition was manufactured at the Denver Ordnance Plant, and DuPont operated a dynamite plant near the city limits.

After the war, the suburbs boomed as the number of automobiles increased, and freeways were constructed. Between 1945 and 1983, one million newcomers arrived in metropolitan Denver, and the city continued to expand outward. During the 1960s and '70s, a spasm of urban renewal resulted in the destruction of countless historic treasures downtown until wiser heads prevailed, disagreeing that the past must be erased to make new history. Larimer Square was restored, becoming Denver's first historic district, and the deteriorated Lower Downtown business district was transformed into "LoDo," a vital social and business center.

Oxford Hotel

First-class accommodations just one block from Union Station—it sounded wonderful to tired train travelers in 1891. The Oxford was a marvel of modern technology and Gilded Age opulence with its own power plant, an efficient steam heating system and the latest in electric and gas lighting. There were bathrooms on each floor with separate water closets, each containing a toilet. The modern kitchen was well equipped with high-powered ranges, broilers and ovens, ready to turn out gourmet meals. Guests dined on fine Haviland china and used silver utensils. The Oxford Club, an exclusive dining room, served politicians, businessmen and bankers who preferred closing deals privately. The lobby gleamed with silver chandeliers, stained glass, marble floors, imported carpets and original art. The "vertical railway" carried guests to the upper floors, where they had a bird's-eye view of Denver's bustling business district. The Oxford had a barbershop, a Western Union, a pharmacy, a library and a relaxing saloon.

Built at the height of Colorado's silver boom, the hotel survived and prospered through the depression that followed the repeal of the Sherman Silver Purchase Act. There were few vacancies, and two additions expanded the capacity of the five-story brick building. Travelers appreciated its luxurious comfort and reasonable rates. Brochures advertised "Fire Proof

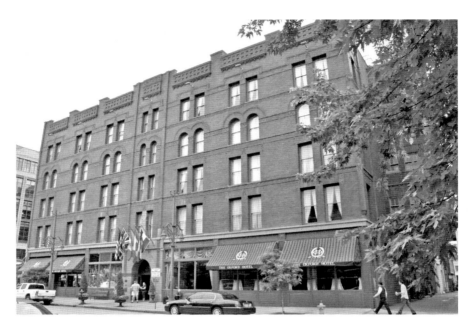

The Oxford Hotel, near Union Station, was convenient for train travelers. *Amanda Williams.*

European Plan…Rooms $1.00, $1.50 and $2.00 a day." The *Denver Republican* reported in 1909, "the Oxford ranks with the Brown and the Albany in the number of daily arrivals, averaging six full register pages every 24 hours."

In 1933, the day after Prohibition was repealed, the Oxford opened the Cruise Room, the first bar in Denver after a long dry spell. This Art Deco cocktail lounge was patterned after a first-class lounge on the *Queen Mary* with a distinctive Streamline Moderne design, popular in the 1930s. Its pastel orange walls feature bas-relief panels of merrymakers painted by Denver artist Alley Henson. Celebrities, politicians and athletes sipped sophistication in this high-class cocktail lounge with its red neon lighting, original sparkling chrome and chilled martinis. The Cruise Room, on the National Register of Historic Places, is a LoDo hotspot and much more than a historic upscale gin joint.

The Cruise Room was the favorite watering hole of poet Tom Ferril, whose friends in the "Wasted Friday Afternoon Club" gathered for cocktail-hour seminars to discuss bawdy limericks as Ferril played the mandolin. Once, they celebrated his birthday by presenting him with a genuine live "Rocky Mountain canary" (a burro). The critter created quite a ruckus in

the bar, making as much racket as the 1979 celebration when Ferril was named Colorado's Poet Laureate.

During World War II, servicemen crowded this lounge, sharing worries about their uncertain futures and toasting hopes for an Allied victory. Many spent a night or two at the hotel and, when all the rooms were full, bunked in a linen closet, the attic and alcoves—wherever a cot would fit.

Newspapermen hung out at the Oxford, and its lobby was packed with reporters puffing cigarette smoke and telling jokes. The *Denver Post*'s wisecracking Gene Fowler kept things lively, and everyone wanted to hear war correspondent Ernie Pyle's opinions.

When the war ended, automobiles were more affordable, and train travel declined. The Oxford, surrounded by a deteriorating downtown, fell on hard times and became home to pensioners, draft dodgers, railroad workers and hippies. There were bright times, too, when hot musicians and comedians made the hotel their home. Some of the best bluegrass, jazz and folk music could be heard here. Peter, Paul and Mary harmonized, and young John Denver sang of "Rocky Mountain High" in the Corner Room, where alternative concerts, drama and melodrama drew crowds.

By 1979, the hotel had been purchased by Charles Callaway. Dana Crawford, a historic restoration expert, joined him in the project to rehabilitate the Oxford and revive its spirit. The original blueprints, unearthed in the basement, and original photographs guided them. False ceilings were removed, revealing the original pressed tin; paint was scraped from the woodwork; and sterling chandeliers were polished. The hotel was rewired and re-plumbed, and a new heating and air conditioning system was installed. New carpet, duplicating the original, was laid, and antiques and Art Deco furniture purchased in Paris and London replaced the fine pieces that had been removed during the 1950s.

After a three-year renovation costing $16 million, the Oxford reopened in June 1983 as an elite luxury hotel. In 1986, McCormick's Fish House moved into the Corner Room, and the bar became a popular place for happy hour. Three rare stained-glass windows, depicting Dutch scenes that had graced the Oxford Club, were hauled out of storage. They were repaired by the original artist's grandson and now can be admired in the bar.

The debts piled up, and the Oxford went through two Chapter 11 bankruptcies. In 1990, Sage Hospitality took over, and its fortunes have turned around. It has hosted Lauren Bacall, Kid Rock, Robert Redford, the Dalai Lama, President Clinton and Secretary of State Hillary Clinton. The Oxford was placed on the National Register of Historic Places in 1979.

Ghosts

Thousands of train travelers have snoozed at the Oxford, but some have missed that last train to eternity and linger here. Some, like the obsessive mailman who haunts the Cruise Room, are doomed to repeat an event over and over. The mailman stopped by the lounge one wintry day for a quick beer before heading for Central City with a bag of Christmas gifts for the miners' children. He sat in the corner, nursing his lager and was overheard muttering to himself about getting the gifts to the kids. He was reluctant to leave the warmth of the lounge—a premonition? When he left, his beer hadn't been touched. The poor mailman became lost in a fierce snowstorm, and it was days before his frozen body, surrounded by Christmas packages, was found. Doomed to repeat that fatal journey, the mailman occasionally drops by to nurse his beer in the corner, and then he fades away.

Ghost tours through the hotel often ventured into the attic and got a scare for their trouble. The groups have been startled by boxes moving across the floor without anyone touching them. One woman heard loud footsteps behind her, and when she turned around, no one was there. People often get a strong sense of foreboding here.

There have been plenty of complaints about a peeping Tom who bothers ladies in the basement restroom. This snoopy spirit has a grizzly beard, curly hair and a ruddy complexion. He suddenly pops up and peeks over the top of stalls and creates a disturbance by rattling the doors.

A caterer setting up for a special event in the Grand Ballroom was startled to see a group of men playing cards and smoking cigars. She stepped out to check on the reservation and returned to find an empty room with nothing but a lingering aroma of cigar smoke. Employees, guests and participants in ghost tours notice this aroma in the ballroom.

Room 320, often called "the murder room," is haunted by a sad spirit whose love story went dreadfully wrong here. An attractive young wife and her lover regularly rendezvoused at the Oxford in their favorite room, 320. They sipped cocktails in the parlor and then enjoyed that comfortable bed. It still has its unique wooden headboard inset with a large metal plaque bearing the words in capitals, "COME GENTLE DREAMS—THE HOURS OF SLEEP BEGUILE." The lovers' sweet dreams ended one night when her suspicious husband followed his wife and broke into room 320, catching them together. Waving a pistol about, he chased the man out of the room and then returned to end his wife's cheating with a few well-placed bullets.

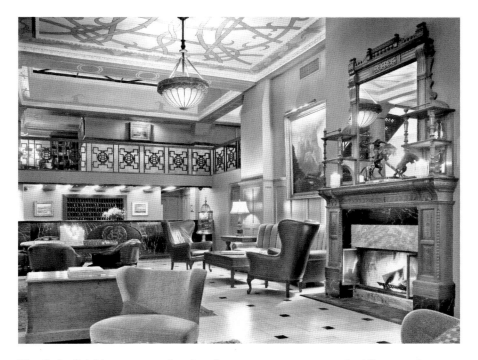

The Oxford's lobby was a popular place for newspaper reporters and soldiers to gather during World War II. *Amanda Williams.*

Now her lonely spirit haunts this room. She doesn't usually appear to couples but prefers men alone. Sometimes a man awakens suddenly to find a woman standing at the bedside or drifting about the room. He might be awakened by the bathroom door opening and then closing. Then the bedcovers are lifted slightly, and there's a movement like he's been joined in bed. The terrified guest usually leaps up and heads for the front desk to demand another room.

Contrary to the usual paranormal activity, one woman who stayed in room 320 was awakened by a "glowing light" coming from the bathroom. The door opened and closed several times as she watched a very large, "sickly white light" float around. It gradually faded away inside the bathroom, the door closed and remained shut the rest of that night.

Brown Palace

Henry Brown had itchy feet, and his wife, Jane, was exhausted. She'd been traveling on foot with her husband, baby son and a wagon piled high with their belongings for six weeks. They'd left St. Louis in 1860 because Henry was eager to return to California, where he'd spent time in 1852, before hopping a ship for South America. He lingered there five years, and when he finally returned to his Ohio home, his first wife had died, and her parents were raising his children. Brown decided this was a satisfactory arrangement and headed west again, stopping off in St. Louis to marry his second wife, Jane. She insisted that Henry settle down, so the couple set out to make their home in California. That decision changed when Jane saw the looming Rockies, and she refused to go any further. Denver would be their home.

Henry acquiesced, and since he'd already made and lost a couple of fortunes, he began building another. He homesteaded 160 acres of land on the hills east of Denver and built a small house. Optimistically, he began laying out streets and lots on his property and then bought another triangular piece of land for a cow pasture. Brown speculated in real estate and was involved in plans to bring a railroad to Denver, realizing its positive effects on the young town's future. He became a charter member of the Denver Board of Trade and donated ten acres of land for the site of the new state capitol building. Dubbed Capitol Hill, land values increased here as the new mining millionaires, the Silver Kings, built palatial brownstones on its slopes.

By 1889, Henry Brown was one of the wealthiest men in Colorado, worth $5 million. When he walked into Denver's swank Windsor Hotel, he was escorted out because he was dressed like a cowboy. As a result, the furious millionaire decided to build his own hotel, one much finer than the Windsor. Deciding his triangular cow pasture would be the ideal spot, he hired Frank Edbrooke, Denver's top architect, to draw up the hotel plans.

The massive, triangular-shaped building had a steel frame and was made of Colorado red granite and Arizona sandstone. Its palatial eight-story atrium/lobby rose to a stained-glass ceiling, illuminated by a skylight, and featured graceful, open Florentine arches and elaborately designed, cast-iron balcony railings. There was a large fountain in the center of the lobby, and the walls, wainscoting and towering pilasters were beautifully swirled golden Mexican onyx. The lobby glowed with sunlight from above, and a massive fireplace with solid onyx pillars dominated one wall. Because of its triangular shape, every room faced outward with a view of the plains or Rocky Mountains. Completed in 1892, the hotel was praised in *Scientific*

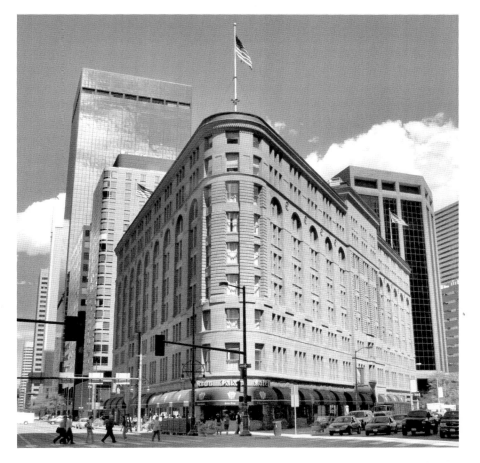

Opened in 1892, the Brown Palace was one of the most luxurious hotels in the nation. *Amanda Williams.*

American as the first fireproof building in the nation, and it had its own wells, a huge incinerator, steam heat and a ventilation system.

There were two elevators, and the two-story dining room, high on the eighth floor, seated 250 guests, who raved over the panoramic views of the mountains. This floor contained a two-story ballroom where guests danced the night away. Most guest rooms had fireplaces and were furnished with expensive oak and cherry French antiques and Brussels carpets. Over half had private baths.

One year after opening his $2 million hotel, the Silver Panic of 1893 wiped out the fortunes of many millionaires, including that of Henry

Brown. Then, his beloved wife of thirty years, Jane, died. One year later, no longer a rich man, the seventy-four-year-old widower married Mary Matthews, a nineteen-year-old grocery store clerk. The marriage lasted six years, until Mary met a much younger man. The Browns divorced in 1900, and she remarried soon after. Relations remained cordial, and Henry often visited the newlyweds.

During the depression that followed the Silver Panic of 1893, Henry managed to hang on to his hotel by mortgaging it. After seven years, weary of battling the creditors on his doorstep, he sold the mortgage of $800,000 to Winfield Scott Stratton, Cripple Creek's first millionaire. Stratton, a generous, eccentric carpenter turned prospector who struck it rich, gave Brown a suite in the hotel for life. In 1906, Henry took a trip to San Diego, where he died. His body was returned to Colorado and lay in state in the capitol that had been built on land he'd donated. When Stratton died, the hotel changed hands, and in 1922, Charles Boettcher bought it. During the Depression, his brother, Claude, joined the operation.

In 1911, the Brown Palace was the scene of a bloody drama that filled the Denver newspapers with scandal and juicy gossip. Mrs. "Sassy" Springer, a beautiful and flirtatious divorcee and the second wife of banker and rancher John Springer, had a country estate and a Capitol Hill home, but she also kept a suite at the Brown Palace for "special entertaining."

She was busily carrying on a flirtation with two lovers, Sylvester von Phul, a wine salesman, and Harold Henwood, a mining promoter. Both men lived at the Brown Palace and were jealous of Sassy's attentions to the other. One evening when the two were in the hotel's Marble Bar, an argument quickly escalated to a brawl, and Henwood shot von Phul in the back. Two stray bullets killed a bystander and wounded another. Henwood was arrested, and von Puhl died that night. The murder trial was lengthy and scandalous, and the newspapers, filled with details of Sassy's torrid rendezvous with her lovers, kept readers in a dither. Her salacious love letters to the two men were aired in court, titillating society matrons and infuriating John Springer. Henwood was sentenced to life in Territorial Prison, and the Springers divorced.

During Prohibition in 1929, the Veterans of the Spanish-American War held its annual convention at the hotel, and arrangements were made for appropriate refreshments. A local bootlegger set up his bar in room 929 and commenced business with the old soldiers. However, a few of the vets talked too much downstairs, and federal agents got wind of the bar. They raided the room, seized the booze and put an enormous padlock on the

door. For over a year and a half, hotel guests gawked at the padlock, until 1931, when the hotel finally proved its innocence in the affair. Only then was that padlock removed.

An ill-concealed secret were the tunnels from the Brown Palace's Gentlemen's Club that ran under Tremont Street to the Navarre, a house of ill repute. Bootleg gin was stored in these tunnels until bartenders added caramel coloring and spices before serving it in the Tea Room. The booze was poured from sterling silver teapots into china cups for thirsty customers. Today's patrons can have their beer served Prohibition style in the Ship Tavern, which opened in 1934 to celebrate the repeal of Prohibition.

During the Depression, the two top floors were converted into luxury residences with plenty of glass, brick and Art Deco touches. Capitol Hill mansion owners, who were tightening their belts and finding tenants for their own homes, snapped up these plush apartments.

The Brown Palace was considered one of the finest in the world, and it was a favorite of dignitaries and celebrities. Its visitor list included Buffalo Bill, Helen Keller, Sarah Bernhardt and Zsa Zsa Gabor. The hotel has hosted every president since Teddy Roosevelt through Bill Clinton. The only exceptions are Coolidge, who never visited Colorado, and President Obama.

In 1905, Teddy Roosevelt hosted a huge banquet where guests consumed five hundred bottles of champagne and 1,500 cigars as he told raucous stories about his Colorado hunting trip. Teddy banged the table and led the singing, and when the gala concluded, tipsy guests escorted the jubilant president to his private railroad car and waved him off.

Teddy's cousin, Franklin, stayed at the Brown in 1932 when he was the Democratic candidate for president, and his visit was much more subdued. The Presidential Suite in Eisenhower's day was paneled in knotty pine, and in 2000, the Ronald Reagan Presidential Suite and the Teddy Roosevelt Suite were added.

Mamie, a Denver native, and Ike Eisenhower often spent weeks at a time at the Brown, which became the Western White House when he was president. When Ike suffered a heart attack in September 1955, he recuperated at the Brown Palace. His personal chef developed special menus around the new dietary restrictions.

Molly (Maggie) Brown, of *Titanic* fame, usually stayed at the Brown Palace in room 629 after she and her husband separated. She took singing lessons there, and other guests complained bitterly, describing the racket as "caterwauling." Maggie was active in numerous charities, and at Christmas

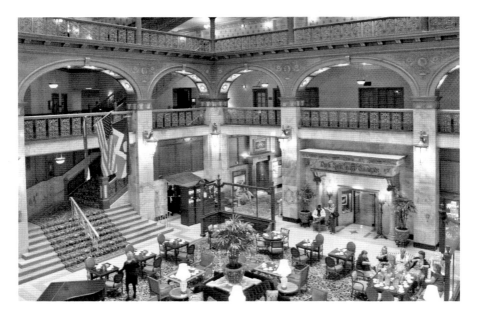

Every January when the National Western Stock Show ends, the Grand Champion Steer joins the ladies in this lobby for high tea. *Amanda Williams.*

1909, she and billionaire Benjamin Guggenheim threw a huge holiday party at the hotel for Denver's underprivileged children.

Socialite Evalyn Walsh McLean, the pampered daughter of Ouray's gold millionaire, Tom Walsh, often spent weeks in her hotel suite. She flaunted the forty-five-carat Hope Diamond and the ninety-four-carat Star of the East at fancy society events and then stashed these priceless jewels in the Brown's safe.

In 1964, the Beatles snoozed in suite 840 after their performance at Red Rocks. An iron-barred gate barricaded their suite, and police flanked the entry twenty-four/seven. Sentries guarded the elevators and hotel entrances to keep frantic fans at a distance.

Entourages of foreign royalty, celebrities and sports heroes have paraded across the Brown's elegant lobby, and rodeo trick rider, stuntman and cowboy star Monte Montana often rode his horse, Rex, up the hotel's grand staircase, roping the manager on the way. In 1985, Marathon Hound, the "winningest greyhound" after setting a world record, arrived at the hotel in a limousine. He signed in with a paw print and was escorted to his luxury suite, where a silver water bowl, a bone and personalized stationery awaited him.

Movie-star dogs and even a chimpanzee, named Kokomo, have enjoyed their luxurious digs at the Brown Palace.

The highlight of the National Western Stock Show is a visit of the "Champ." The red carpet is rolled out, and the Grand Champion Steer strolls into the lobby with a garland of flowers around his neck. He takes his place in a special pen next to the ladies enjoying high tea. The champ savors his moment in the spotlight, drinking from a silver punch bowl, and then poses for newspaper photographers and has his picture snapped with guests.

In 1959, the Brown Palace West addition across Tremont Street added 288 guest rooms. Over the past one hundred years or more, since opening in 1892, the Brown Palace has never closed its doors.

Ghosts

The Brown Palace is so luxurious you'll want to extend your stay—as so many guests have, lingering for eternity. The houseman investigating sounds coming from the San Marcos Room, now Ellyington's, was surprised to see an unfamiliar string quartet of formally dressed musicians practicing. He told them they should leave so he could clean the room. "Oh don't worry about us," they replied. "We live here." Then they vanished.

Socialite Louise Crawford Hill, who had many amorous flings and was the recognized leader of Denver's elite society, lived in one of the plush Skyline Apartments on the top floor with her staff for fifteen years, until she died in 1955. Years later, the hotel historian developed a tour called "Affairs of the Heart" in which she told about some of Mrs. Hill's romances. During this tour, the hotel switchboard was flooded with calls from Mrs. Hill's apartment, room 924. When the operator answered, she only heard static. This was really strange because there was no phone in that room or any of the others on the top floor, having been removed in preparation for remodeling. Finally, the historian stopped airing Mrs. Hill's dirty laundry, and the calls ceased immediately.

Once there was a railroad ticket office in the lobby, and occasionally, a man wearing a conductor's uniform rushes across the lobby and walks straight through the wall of the former office. Telephone operators have been surprised when a pretty woman in a long, pink ball gown enters their office and disappears through another wall. Laughter and giggling are heard near room 804, which was once part of the grand ballroom, and children's voices are noticed in the upstairs halls when there are no young guests.

Occasionally, a uniformed waiter who's strangely silent takes the service elevator and then vanishes in front of your eyes. There are persistent rumors of a baby crying in the boiler room, and some believe a physician disposed of a stillborn in the hotel's incinerator.

A maintenance man was summoned to room 523 to adjust the heat, and his knock was answered by a pale, elderly woman in a long black gown. He adjusted the thermostat and, since the guest wasn't around when the job was completed, reported to the front desk. He was greeted with silence by the clerk, who said, "That room is vacant."

Lumber Baron Inn

This impressive Queen Anne–stlye mansion was built in 1890 by lumberman John Mouat. The three-story brick and sandstone home is one of the largest in the Potter Highlands Historic District, where Mouat lived with his wife and five children. A Scotch carpenter, Mouat started a lumber company in 1873, capitalizing on Denver's construction boom, and made a fortune in real estate.

Mouat built an 8,500-square-foot house, showcasing beautiful varieties of wood: maple, poplar, oak, cherry, sycamore and walnut. The front parlor was done in cherry, while the rear parlor featured sycamore. The dining room was oak decorated with hand-carved rosettes of cherries, plums, apples, grapes and acorns. The fireplace was framed with inlaid, hand-painted tile featuring colorful hunting dogs pursuing a stag. It was topped with an elaborately carved oak double mantel. The third-floor ballroom had a twenty-foot-high pyramid ceiling, a shining maple floor and a uniquely manteled fireplace.

The economic depression of 1893 was disastrous for Mouat because construction stopped, and real estate values plunged. He lost his home to the bank in 1897 and moved his family to San Diego, where he died in 1934.

The mansion changed hands several times, and it became the home of the Denver Business University in 1904. Hiram Fowler purchased it in 1909 and converted it into small apartments and offices. When he died in 1940, it ended up in the hands of James Fowler, a relative, who carved the place into fifteen tiny low-income apartments. He plowed up the yard, front and back, for an organic garden and sold the vegetables at a co-op he organized. Fowler raised earthworms in his "organic worm house" in the backyard and

Built in 1890 by a lumberman as a family home, the Lumber Baron Inn showcased many varieties of beautiful wood. *Amanda Williams.*

became involved in recycling and community gardening, teaching classes in organic gardening at the mansion. Fowler's ideas for vacant lot gardens became so popular that city hall embraced the effort in 1974, opening some city-owned, vacant lots to seniors for community gardens. Fowler's ideas eventually grew into the Denver Urban Gardens Project.

Fowler died unexpectedly in 1981 in a fall at the house. There were suspicious rumors about the accident, but his death was never investigated. The mansion's charm was gone, as it became a flophouse with an ever-changing number of units and transient tenants. In 1991, the bank foreclosed on the deteriorated building, hidden by weeds and looking like a haunted house.

Newlyweds Walter and Maureen Keller purchased the place on April Fools' Day 1991 for $80,000. They spent the next year living in the dining room, the only room with dependable heat, sharing space with

their three Dalmatians. They named their place the Lumber Baron Inn and began restoration.

The old mansion had been plundered and looted over the years, and many of the original fixtures had been removed. The stained-glass windows were stolen; silver fixtures, hinges and doorknobs were missing; chandeliers had been swiped; and eight handcrafted wooden fireplace mantels were gone. The hardwood floors had been torn up and the expensive wood taken; someone had even tried to steal the hand-carved oak newel post at the base of the staircase. The Kellers scraped off layers of flaking paint; removed stained, torn wallpaper; scrubbed off graffiti; and removed fourteen tiny kitchens and makeshift bathrooms. Since little maintenance had ever been done, there were endless repairs and rewiring and replumbing expenses.

A lot of work and money were required before the Lumber Baron Inn could be opened as an event center and bed-and-breakfast. Now, the Murder Mystery Dinners are very popular, and the Magic Shows and Casino Murder Mystery Nights draw fans who have as much fun participating as the stars do.

Ghosts

Despite repairs and renovations, the inn still has plenty of unexplained creaks, groans and cold spots. Steps are heard on the stairs when no one is around, and occasionally, an apparition of a woman appears on the stair landing. She's wearing a Victorian dress, has her hair in a bun and has her arms crossed. Walt describes her as looking "rather school-marmish." He speculates she might have been an instructor at the Denver Business University. Many people have caught a glimpse of this woman in the front parlor mirror, and Keller says he sometimes feels like he's being watched when he's in the foyer.

This old mansion was the scene of a double murder in October 1970, and the crime has never been solved. Cara Lee Knoche had moved into the tiny, one-room apartment in this run-down old house just before her seventeenth birthday. She shared the forty-eight-dollar monthly rent with a roommate who was out of town that fateful October night. Marianne Weaver, an eighteen-year-old friend, came by in the evening to visit Cara.

Around three o'clock in the morning, another friend drove by, noticed Marianne's car in front and wondered why the lights in Cara's room were out. Deciding to investigate, he went upstairs, found the door to Cara's room

slightly ajar and entered. Marianne was lying on top of the bed, a bullet hole in her forehead and her hands folded across her chest. Cara's nude body was half under the bed. An autopsy determined that Cara had been raped and strangled, and police speculated that Marianne was shot when she interrupted the attack. An investigation was launched and a reward offered, but the crime remains unsolved.

Keller said while working near the Valentine Suite, where the murders occurred, "I felt like something was standing over me—watching. When I looked over my shoulder, I saw nothing." Guests in the Valentine Suite have sensed something hovering nearby, and cameras have captured filmy images in the room.

The apparition of a young woman wearing a blue flapper-style dress has been seen in the ballroom. This space is often used for weddings and receptions, and this spirit has startled several guests and at least one mother-of-the-bride. While arranging bouquets of flowers, she noticed a young woman seated near the front window, sipping champagne. When

The Lumber Baron has a few wispy residents from another time who approve of its extensive restorations and will probably stay for another century. *Amanda Williams.*

the mother approached, there was a sudden whoosh of cold air, and the figure vanished.

Mile-High Paranormal investigated the mansion on the murder anniversary in 2000. Dee Chandler, a paranormal expert and founder of the group, said, "Everyone experienced something that night." She glimpsed a woman's face in the Valentine Suite's mirror and says the spirits of the girls are restless because their murders remain unsolved. While she was alone in the dining room, Dee said, "Something whispered in my ear." One ghost hunter captured a blurry digital image of a black cat on the transom of the murder room. Chandler detected a protective male presence upstairs that she called "the General," and she associated this spirit with the aroma of tobacco smoke. The presence of a black woman, possibly a maid, was picked up, and most sensed a "mischievous flapper." When everyone was gathered in the kitchen, they were startled by the refrigerator, which shifted back and forth on its own. Altitude Paranormal has conducted several investigations at the inn and snapped a photo of an apparition in the ballroom. It can be viewed on the group's website.

Spirit Paranormal Investigations has visited the Lumber Baron several times and led dozens of investigations there. Its members have taken many photos of orbs throughout the building. Ghost Hunters University held several national seminars at the inn, where Ghost Hunting 101 taught attendees how to use scientific methods to detect entities from other worlds. The Lumber Baron Inn made the cover of its magazine, *Haunted Times*.

The Kellers' son, John, was born while they lived at the inn, and as he grew older, he often talked of the "Nicey Nice Ghost" that shared his room, remarking, "Every morning he says hello." John was never frightened of this spirit and described him as a teenage boy with a funny nose. While talking about the Lumber Baron's unseen but permanent residents, Walt Keller told a *Denver Post* reporter, "What's fun is that even when we're alone, we never feel alone."

Patterson Inn

The towering red sandstone castle looks elegant and haunted. Rumors have swirled around its brooding turrets and towers for years—a dead baby buried in the basement, mysterious footsteps and ghostly images, evil black mists and sobs and cries in the night. The Croke-Patterson Mansion, now

known as the Patterson Inn, has left many with a feeling of sadness and loss. Others sense tragedy, fear and a lurking evil.

The three-story mansion, completed around 1892, resembles a sixteenth-century French chateau with its towering chimney, slate roof and stained-glass windows. Wealthy carpet dealer Thomas Croke built it for his family, but his wife died soon after the place was completed. Croke moved his parents and children into the house, and then his mother died. Within six months, Croke traded his mansion for land owned by Thomas Patterson. He developed a system of irrigation ditches north of Denver, regaining wealth he'd lost in the 1893 depression.

Patterson, a successful lawyer, moved into the mansion with his wife and daughters. Shortly after, his son in California committed suicide. Then, his chronically ill daughter, Mary, died. Patterson was elected to the U.S. Senate in 1901, but his victory was saddened by the death of his wife, Katherine. The senator gave the house to his daughter Margaret and her husband, Richard Campbell, but lived with them until his death in 1916. The Campbells sold the place in 1924, and it was converted into office space and apartments.

Dr. Arthur Sudan purchased the building in 1947, using one unit for his office, while his family lived in another. The doctor's wife, Tulleen, a nurse who'd worked with him for years, committed suicide in 1950 by inhaling

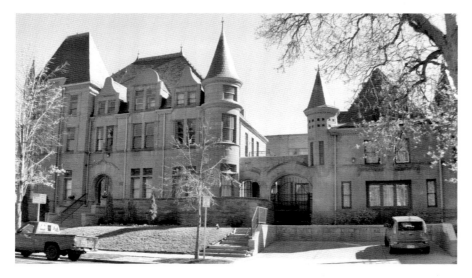

The Croke-Patterson Mansion, now known as the Patterson Inn, was placed on the National Register of Historic Places in 1973. *Amanda Williams.*

poisonous gas. The grief-stricken physician remained in the house and married his neighbor five years later. The mansion was inherited by his son, Archie Sudan Jr., a physician, who set up his office in the basement and continued renting the apartments, finally selling the building in 1972.

Ghosts

The mansion fell into disrepair and was so neglected that it was scheduled for demolition when Mary Rae rescued it. Renovations were so expensive that little could be done, but Mary worked tirelessly to get the place listed on the National Register of Historic Places. Tenants moved out, complaining about a baby who cried at all hours and a disruptive racket on the third floor that kept them awake.

There wasn't any baby, but there were plenty of rumors about an infant who had died there whose grief-stricken mother had committed suicide. Some said that she retrieved the tiny corpse from the cemetery and buried it in the basement before killing herself. A psychic was certain "something" was buried in the basement, but an excavation only turned up sand.

Terrible noises came from the third-floor unit in the northwest corner of the building, but nothing was found. Once when Kevin Pharris of Denver History Tours led a group around the neighborhood, the house was on the market, and a realtor invited them inside to look around. When they entered the third-floor corner room, everyone in the group felt a definite chill.

A tenant was brushing his teeth in the second-floor bathroom when something behind him began rattling the shower curtain around the tub. Thinking it was one of his cats, he checked—no cat. He continued brushing, and suddenly, the curtain and shower rod flew across the room, straight at him. Terrified, he ran out of the bathroom.

A tenant called Mary Rae to his first-floor apartment that was once Patterson's library. A very large, heavy wood and brass fireplace insert was sitting in the middle of the room instead of inside the fireplace where it belonged. The tenant was very upset because the place was a mess, saying it had been torn up and the insert moved from the fireplace while the family was out. He was so disturbed by the chaos and the strange things that had been happening in his apartment that he called a priest to perform an exorcism. As the priest began praying in the front parlor, plaster started falling from the walls, and then a huge puff of black smoke blew out of the fireplace. The choking black clouds continued until the frightened priest stopped praying

and quickly left. Mary and others attending this ceremony were so terrified that they made a pact to never talk about it, and her tenant moved out.

The old mansion was placed on the National Register of Historic Places in 1973, and then the Raes sold it. Work began to convert the apartments into office space, and paranormal activity increased during the construction. Workers' tools were often misplaced, and progress was slow because the completed work was often undone during the night. The job would have to be redone the following day. To protect the work site, a fence was erected around the building, and three Dobermans were left inside to guard the place at night. One morning, construction workers found two of the dogs lying dead on the sidewalk. They'd apparently jumped out through an upstairs window. The third dog was in the third-floor tower room, absolutely terrified and shaking. What could have frightened these dogs so badly that they jumped out a window to their deaths? Tale of ghosts escalated, and most workers tried to avoid the cold, chilly basement. One man said, "[It] sucked the life out of me."

The mansion soon had new tenants because office space in this Capitol Hill location rented quickly, but it wasn't long before they began worrying about the unusual things that happened. Typewriters clacked away by themselves at all hours of the night, and light bulbs burned out as fast as they were replaced. Xerox machines turned themselves on, generating stacks of unwanted copies. The phones rang, and no one was there, or there were busy signals for hours. Sometimes the phones rang continuously, driving everyone crazy. The telephone company became as frustrated as the office workers from their frequent trips to the mansion.

Much has been written about the Patterson Mansion, and one of the most thoroughly researched books is by Ann and Jordan Leggett, who spent a lot of time there with various psychics and mediums and accompanied paranormal investigation groups. One psychic saw the apparition of a woman standing on the main staircase and said there was a strong level of energy on the main floor. She sensed three "dark spirits" in the basement that wanted them to leave immediately. She felt sick in the bathroom where Tulleen Sudan gasped her last breath. Without knowing the room's history, she, too, gasped, "There is death in this room…suicide."

Psychics, mediums and those who are more sensitive have experienced respiratory discomfort on the third floor, reporting that it seems suffocating and oppressive. It's common to have camera and battery problems here, and the small tower room is particularly disturbing to many. What frightened the guard dogs so badly that they jumped out the window?

The mansion has been investigated several times by Rocky Mountain Paranormal Research Society, and some mediums and psychics have returned more than once. Their experiences intensify with each visit, and one medium said it took her days to shake off the melancholy she experienced afterward. Some people who are attuned to paranormal activities pick up the presence of an apparition of a frail woman on the main staircase and on the third floor. She's usually described as pale, sick or having trouble breathing. A former tenant, pregnant with twins and bedridden, said a woman suddenly appeared at her bedside and extended her hand, saying, "I'm Kate." She helped the expectant mother get comfortably positioned and then just faded away. Was this apparition Katherine Patterson, who died here?

One long-term tenant decided she'd live peacefully with the different spirits she was encountering in the mansion. She recalled sitting on the couch with her husband in his third-floor office, watching the drawers of his desk open and close by themselves. The Spirit Paranormal group conducted three different investigations of the mansion and recorded the sounds of a drawer opening and closing in this same room.

A skeptical man, who accompanied Spirit Paranormal on an investigation of the mansion, wanted some type of response from a spirit and questioned whether any were really present. Sitting on the staircase, he banged loudly two times on the steps and then demanded a response. Everyone was startled by two resounding thumps coming from the empty basement. The doubter thumped three more times and got a response again. Suddenly, a black, misty cloud drifted up the steps from the basement. Everyone screamed, and the mist disappeared. After that, the skeptic was quiet, no longer issuing challenges and no longer doubting that the mansion is haunted.

Once again, the Patterson Inn has new owners, who've renovated it and converted it into a luxurious bed-and-breakfast. Hopefully, its old tenants will welcome their new overnight guests.

9
BOULDER

The sheltered valley at the base of the red rock monoliths that tilt up to meet the sky was well known to the nomadic Southern Arapahos. They'd seen Zebulon Pike's exploring expedition in 1806, followed by Stephen Long in 1820. Explorers and mapmakers, Gunnison and Fremont followed in the 1840s, and then the Pikes Peak Gold Rush brought thousands more.

In October 1858, a party of Nebraskans pushed on toward the tilted rock slabs where Boulder Creek rushed out of a canyon. When they panned in the creek and its tributaries, they found gold and set up camp for winter. They built eleven cabins and named the place Boulder City. A few prospectors ventured up other nearby canyons, looking for gold. During the surprisingly mild winter, they continued to prospect. When spring arrived, the gulches swarmed with eager hopefuls who'd heard about the rich veins of gold that had just been discovered. A new camp, Gold Hill, sprang up in the canyon west of Boulder City.

The Boulder City Town Company was formed in February 1859, and a town was mapped out two miles long on both sides of Boulder Creek. Lots were sold for $1,000 apiece, but the price was too high for most to pay. Prices were lowered, but growth remained slow, and by 1860, Boulder's population was only 324. Most of the new town was a part of Nebraska Territory, with Baseline Road as the southern boundary, separating it from the Kansas Territory.

When Abner Brown passed through Boulder, he noticed about forty children running loose. He prevailed on their parents to let him start classes

in the "spare" room of a two-room cabin occupied by a family of five. After about three months of this, Abner shamed the town fathers into building a school. He did all the carpentry work in exchange for free board. Brown built a lathe and plaster schoolhouse and fashioned a heating stove from scrap iron he found at an abandoned placer digging. On October 15, 1860, the school opened—the first one in the Rocky Mountains.

In 1861, the Territory of Colorado was established, and Boulder City was named the county seat of the new Boulder County. The town became a supply center, with hardware stores and merchants selling dry goods, mining equipment and groceries. There were boardinghouses, saloons and restaurants. Boulder City citizens began lobbying the territorial legislature to have a state university located there, knowing it would bring more settlers and increase real estate values. Boulder was incorporated in 1871 and dropped "City" from its name. The railroad chugged into town in 1873. A hospital was built, and by 1874, Boulder had a city water system and had won the University of Colorado. A forty-five-acre site had been donated, and citizens raised $15,000 to match a building grant from the legislature.

"Old Main," the first building, sat on "the Hill" and housed the entire university with classrooms, the library, the auditorium and the president's living quarters. It opened its doors in September 1877 with forty-four students, one professor and a president. The steps in Old Main were higher than usual, designed to keep cattle from wandering through classrooms.

By 1880, Boulder's population was over three thousand, and a courthouse and town hall were completed. There was a post office, a telegraph system, a water system and residential neighborhoods. University Hill was growing, and its residents had the luxury of flagstone sidewalks. Pearl Street was the center of town, but it was muddy or snow-packed during the winter and dusty in the summer. Downtown merchants replaced their hazardous, wooden boardwalks with fine, level flagstone sidewalks. Electricity was brought in by 1887, and by 1891, a horse-drawn streetcar was clanging up and down Pearl Street.

In 1893, Colorado became the second state, after Wyoming, to allow women to vote. In 1898, Chautauqua was created as a family retreat, focusing on culture, education, music and nature. The day after the grand opening of Chautauqua, the City of Boulder purchased the eastern slope of Flagstaff Mountain from the federal government, beginning its program for parks and preservation of open space.

On New Year's Day 1909, the Boulderado Hotel, a first-class establishment, opened, and it helped boost tourist travel to the area. By

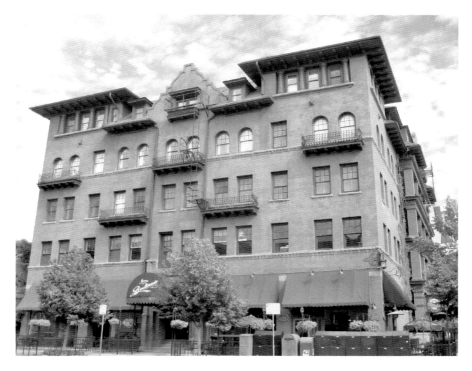

The citizens of Boulder raised the money to build a first-class hotel for their town.

1917, automobiles had become part of Boulder, and a portion of Pearl Street was the first to be paved. There were over six thousand students attending the university, and Boulder's growth was steady. After World War II, veterans attended the university on the GI Bill. The 1950s and '60s saw an influx of businesses after the completion of the Boulder Turnpike. The city continued to purchase land for preservation and passed the Historic Preservation Code regarding the rehabilitation of historic buildings.

BOULDERADO HOTEL

Unlike many grand hotels that were built by wealthy entrepreneurs, the Boulderado is the realization of the efforts of citizens, who raised the money to build a first-class hotel for their community. Times were changing in 1905, and Boulder was being passed by. A mining and agricultural center

with a growing university, the town needed a luxurious hotel to draw more people and business opportunities. To build such a hotel, Boulderites needed to raise money.

The Boulder Commercial Association, a forerunner of the chamber of commerce, sold stocks in the future hotel at $100 a share. By April 1906, enough money had been raised, the site selected, the architect hired and the community had approved the building plans. After months of squabbling, the name chosen for the hotel was "Boulderado," a combination of "Boulder" and "Colorado." The five-story Mission Revival–style red brick building opened on New Year's Day 1909. Most guests paid $1 to $2 a day for a room with a private bath and telephone. The lights could run on gas or electricity since electric power was not reliable on windy days. The huge coal furnace was manned twenty-four hours per day, providing steam heat to the radiators and keeping water hot around the clock. Traveling salesmen were welcome and displayed their goods in the fifth-floor sample rooms.

The original, graceful, cantilevered cherry wood staircase remains. The colorful mosaic tile floor is still in place, and guests register at the 1909 cherry desk. The marble water fountain supplies icy, cold water piped directly from Arapaho Glacier, Boulder's water source. The Otis elevator is over one hundred years old and operates as smoothly as the day it was installed. The stained-glass canopy ceiling over the mezzanine was patterned after one in San Francisco's Palace Hotel with imported Italian leaded glass.

In the dining room, the tables were set with sparkling silver, fine linens, pewter finger bowls and colorful bouquets. A guest could enjoy roast chicken with sage dressing for thirty-five cents, while a multicourse dinner with everything from beef broth to imported cheese and ice cream cost seventy-five cents. A whole pumpkin pie went for only a nickel. After dinner, the gents could relax in the smoking room with a fine cigar selected from the eight-foot-tall glass humidor, while the ladies chatted on the mezzanine, where there were plenty of chaise lounges and rocking chairs.

The hotel didn't have a bar, since the city outlawed saloons and went dry in 1916. After the repeal of Prohibition in 1933, the city was officially dry until 1967. Guests brought their own liquor to their rooms. In 1967, the Catacombs, Boulder's first legal bar, opened in the basement.

The Curran Opera House opened in 1906, bringing performing artists to the hotel. Helen Keller lectured at the university, and Robert Frost was a favorite guest. Everyone was thrilled to see Douglas Fairbanks Sr., Bat Masterson and Ethel Barrymore at the hotel. Enos Mills, the naturalist who was instrumental in the formation of Rocky Mountain National Park, stayed

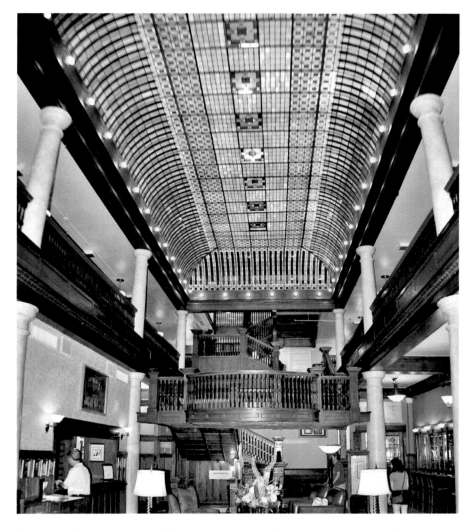

This beautiful glass canopy ceiling is unique, made of thousands of pieces of Italian stained glass.

here. The fiery Evangelist Billy Sunday, with his wife and four children, lived at the hotel for five weeks. Sunday delivered fiery sermons daily to crowds packing the four thousand seats of a specially built tabernacle. In 1920, Franklin D. Roosevelt, the vice presidential candidate of James Cox, gave a speech at a Democratic dinner at the Boulderado. Jazz clarinetist Benny Goodman, the King of Swing, and famous jazz trumpet player Louis Armstrong stayed here while on tour.

The hotel flourished under the management of Hugh Mark, who started in 1917 and kept the doors open through the hard times of the Depression. Mark had a sudden, fatal heart attack in the dining room on July 3, 1934, and was mourned by the entire town. The hotel limped along after Mark's death until Bill Hutson Sr. purchased it. He gave it to his son Bill Jr. and his wife, Winnie, as a wedding present.

Tourism declined during World War II, but after the war ended, Hutson converted the coal furnace to natural gas, replaced the old light fixtures with electric lights and reopened the hotel dining room as a coffee shop. However, it couldn't compete with the latest tourist trend, vacationing in the new, cheaper accommodations of "motels." A fierce snowstorm broke the glass in a rooftop skylight, and the shards fell through, damaging two stained-glass panels, which crashed onto the lobby floor. Although just two panels of glass had broken in the storm, the rest were removed and replaced with gaudy red, white and blue Plexiglas. The imported cathedral glass was hauled to the dump.

A downward spiral began when William Hutson Sr. died in December 1959. Just four months later, Bill Jr., only fifty, died. By 1960, the Boulderado was described as a "rundown, dirty old place with soot on the walls and cobwebs hanging about." The hotel's deterioration continued, and the city declared it a fire hazard. Officials said the grand staircase must be enclosed in fireproof material or a sprinkler system had to be installed. If this wasn't done, the hotel would be razed.

Ed Howard rescued the Boulderado in 1963, installed a $30,000 sprinkler system and began restoring the hotel to its past glory. A succession of owners followed, and William Brantmeyer of Boulderado Plaza Limited took over in 1976. He's remembered for restoring the lobby's stained-glass ceiling. Over 1,500 square feet of new, leaded stained glass were pieced together, following photographs of the first ceiling.

In 1977, the Boulderado was selected as a city landmark, and remodeling began. By 1982, the hotel had been completely restored, and many original pieces returned the lobby to its original Victorian splendor. In 1989, a sixty-one-room brick annex was added with its own stained-glass ceiling. The Boulderado now looks much as it did when it opened in 1909. It was listed on the National Register of Historic Places in 1994 and is recognized as a Historic Hotel of America.

HAUNTED HOTELS OF NORTHERN COLORADO

Ghosts

The presence of ghosts has been felt around the Boulderado since the early days. It's had its share of guests who died natural deaths while at the hotel, and there have been at least three suicides. Guests and employees have had numerous paranormal experiences and encounters with mysterious entities. Guests have heard scratching sounds coming from inside the walls, and one couple was frightened by a loud pounding on the wall. When the desk clerk investigated, the adjacent room was locked and empty. The elevator, which is original to the hotel, has a life of its own, and employees have grown used to its vagaries. It occasionally runs up and down independently, answering mysterious calls. The kitchen staff has become accustomed to the pots and pans swinging about on their hooks when there's no draft, but the chefs do get aggravated when things are moved about or hidden by unseen hands.

A middle-aged couple made a suicide pact to end their lives at the Boulderado. The husband successfully killed himself with chloroform, but the wife didn't have enough of the chemical and ended up in the hospital. The rooms the couple chose for their dismal demise were rooms 302 and 304, and now both have a lot of paranormal activity. The hotel's front desk receives many calls from guests who've been frightened by something or

Room 302 is one of most haunted rooms in the hotel and the scene of a suicide. Voices are heard, shadows flit about and doors open on their own.

have decided the hotel is haunted. The highest number of calls are about rooms 302 and 304.

When a Native American man was given room 302, he refused to enter, saying he "sensed something unnatural in there." When housekeepers are cleaning these rooms, the TV often flips on and off at random, and strange things happen with the antique grandfather clock. It doesn't keep accurate time, and when a housekeeper was working, the clock suddenly went crazy. Its hands started spinning round and round, and it went "cachook, cachook, cachook." The housekeeper said, "Then it suddenly stopped—on the right time!" Several other employees have witnessed the clock's strange activity, which usually starts when they vacuum.

A doctor and his wife checked into this suite, and then he left to attend a seminar. While alone, his wife heard a woman's voice and the sounds of a baby in the room. She said she wasn't frightened, but that she felt a presence with her. She didn't tell her husband when he returned. He was relaxing, planning to watch TV, when he turned to his wife and said, "I think this place is haunted." He had also heard the woman's voice and saw a "filmy white thing" in the dresser mirror. This was soon followed by a dark shadow that passed over the coffee table. He tried to re-create the shadow, but it was impossible. There were no more incidents during their stay, but when they checked out, they talked to the desk clerk about their experiences. They learned others have noticed similar strange things in this suite.

The Boulder County Paranormal Research Society (BCPRS) conducted an investigation of the hotel in October 2007 and posted the group's findings on the Internet. The investigators recorded EVP on the stairs. It sounded like a voice cautioning them to be "careful." Not long after their investigation, Richard Estep, co-founder of BCPRS, received an e-mail from a family who stayed in rooms 302 and 304 when their daughter got married at the hotel. They'd booked the spacious suites with a balcony because it was large enough for a gathering of relatives and friends. After the wedding, the exhausted parents headed for bed. They made sure the balcony doors and those to the suites were locked. During the night, the wife was awakened by the sound of the door into the suite opening. When she got up to check, she found the door closed and locked. She returned to bed, but her sleep was interrupted several more times by the sounds of a squeaky door opening and closing. Frightened of movement near the bed, she pulled the covers over her head and tried to sleep as her husband snoozed peacefully. The next morning, the couple was startled to find both balcony doors were unlocked and open.

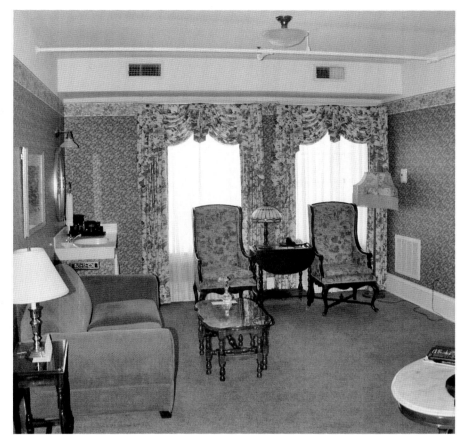

Room 304 has a great deal of paranormal activity and connects to room 302. An apparition of a woman has been seen floating about.

There have been several suicides at the hotel, and there were no notes left behind to explain these fatal actions. On the Fourth of July 1963, the manager was called to "see something" on the balcony of room 214. What he found was a body and a shotgun. There was no note, but the victim, a carpenter in his forties from Pennsylvania, left the receipt for the weapon he'd just purchased. Another puzzling suicide was the young man who'd recently inherited millions of dollars. Apparently, the money wasn't enough, and he was found dead in room 509 with a full bottle of wine, a pipe of hash and his .357 Magnum revolver.

In the summer of 2003, a British couple planning a move to the area made the Boulderado their headquarters while they shopped for a new

home. They'd been there about a week when they were awakened one night by footsteps in the hall outside their fifth-floor room. The husband, a retired British bobby, said it sounded like someone limping or staggering down the hall. He opened the door but saw nothing. The next morning, the elevator operator told them about a young bride whose fiancé had walked out on their elaborate wedding at the hotel. Devastated, she'd rushed upstairs to her room and thrown herself out the window. The couple was staying in this room.

Hugh Mark, the manager who died here, had always made sure things ran smoothly. A longtime employee was eating with friends in the restaurant one summer evening when a heavy window nearby made a creaking noise and opened itself. Everyone sat transfixed as the tall, heavy window slid open without any visible help.

Another hotel employee, who has worked at the Boulderado since 1985, had a strange experience. While working in a room, she tried to open a window, but it wouldn't budge. She went to get some tools and returned to find the window standing wide open. The room was vacant, and no one had been around or knew she needed help. She finished up, closed the window and left. She returned just a few minutes later, and the window was wide open once again. Few people had been in the area, and all denied involvement.

Guests and employees have heard unexplained footsteps and sounds, and when the area is checked, no one's around. Some employees said they felt their hair touched lightly when no one's nearby. When a guest lost her scarf, an employee first checked the lost and found storeroom, but she didn't find it and left, locking the room. The next day, she decided to check again, and when she unlocked the storeroom, she immediately saw the missing scarf draped over a shelf. It had not been there the previous day, and she had the only key to lost and found.

Ben, another employee, saw a dark figure move into an upstairs linen supply closet, followed by sounds of hangers banging together as if someone had brushed by. He called out and was startled to receive a loud answer from the closet. Thinking the figure was an intruder, he grabbed a piece of pipe and quietly approached the closet. Flipping on the light switch, he yelled, "You're not supposed to be in here!" He was dumbfounded to find the room empty with no one in sight.

A woman named Juliann was at the hotel planning a conference when she encountered a lady in a long gray dress on the stairs. Turning for a second look at the old-fashioned figure, she was startled because the lady simply vanished. She described her experience to the manager, who wasn't

surprised, since others have had similar encounters with the "Gray Lady." When Juliann was leaving, she met the Gray Lady again on the stairs, and once again, the apparition vanished. Sometimes the Gray Lady is seen in a rocker on the mezzanine, and she moves about the hotel. Occasionally, a guest awakens to find a woman in a long gray dress, with a shawl draped around her shoulders, standing at the foot of the bed or sitting quietly nearby.

Employees occasionally spend a night at the hotel because of scheduling, weather or additional assignments. While staying in room 505 with a friend, one employee decided to grab a short nap while her friend was on the phone in the adjacent parlor. Dozing off, she saw something red near the bedroom door just as it closed. When she awoke, she joined her friend, who remarked about seeing her in a white night gown just before the parlor door closed. After comparing notes, they knew that they'd both seen something close the door. Her friend was not wearing red, and she had never changed into a nightgown.

The fifth floor has had some strange paranormal activity. A guest in room 511 said he had been awakened by a lady in a white dress who just vanished. In the winter of 2010, at about five o'clock in the morning, another man rushed to the front desk, anxious to check out. He'd been staying in room 511 and said he'd been awakened by a lady in white. "I woke up and saw this figure standing over my bed. Then she went into the bathroom, flushed the toilet twice, then disappeared," he said. "I've never seen anything like it!" Other guests have heard footsteps and sounds coming from room 511 when it's vacant.

10
ELDORA

Eldora is a tiny village, sitting in a wide, U-shaped valley, just three miles above Nederland. Gold mining came late, in 1891, long after the deposits of the sparkly stuff in Boulder Canyon and Gold Hill had been exhausted. Eldora's mines only lasted a few years before the ore ran out, and now the main businesses are skiing and the Gold Miner Hotel.

When John Kemp panned some gold dust from Middle Boulder Creek, he named his claim "Happy Valley." More prospectors discovered several lodes on Spencer Mountain, and by the spring of 1897, the new gold camp of Happy Valley was bustling.

The slopes swarmed with eager men, determined to get their share of wealth. Some found it through hard work and luck, others through trickery. Novice prospectors were easily duped by crooks, who "salted" mining claims by dropping a few gold-bearing rocks on a worthless piece of land. Other unscrupulous conmen loaded some rocks in a sack and hurried into camp to find a sucker, which wasn't difficult. A gold-hungry tenderfoot would be led outside a saloon by the slick expert he'd just met, and the conman would point out "the claim" high up on the mountainside, swearing his rich specimens came from that spot. Never mind that the ore and the claim were buried under a couple feet of snow—riches were waiting once spring arrived to melt the snow. The tenderfoot's enthusiasm wasn't dimmed because he'd seen the gold. Money was exchanged, and when the snow did melt, the tenderfoot hiked up the mountain and learned that he'd purchased a worthless rock pile on a barren cliff.

Happy Valley's name was changed to Eldorado, but it had to be changed again when mail for Colorado was delivered to Eldorado, California, in the Mother Lode. The name of the blossoming town was quickly switched to Eldora, ending the post office's confusion.

Before the town site was surveyed and mapped, lots were sold. Since property lines hadn't been drawn, their legal location was uncertain. Buyers peered at distant mountainside property through binoculars and bought based on a guess at the lot's probable location. In their desire to avoid conflict with the wives of merchants and businessmen, the city planners said that the red-light district had to be built on the wrong side of the creek that ran along Main Street. The working girls complained loudly at being confined to this less desirable part of town, so they decided to dress up their neighborhood. They erected a large sign with a flamboyantly painted, buxom lady, proclaiming "THIS IS MONTE CARLO—Fourteen Beautiful Girls to Serve You."

Construction was started on six new houses every day, and the sawmill couldn't meet the demand for lumber. As a result, daily wagonloads of wood rattled up the canyon from Boulder, and during this building frenzy, anyone who could manage a saw and hammer had a job. Young boys earned a dollar a night just for holding a lantern for carpenters so they could see to drive nails after the sun went down.

Since there was no place to sleep, the lucky ones whose houses were completed did quite well renting sleeping spaces in their spare rooms or attics. One enterprising saloonkeeper placed an extra-thick layer of sawdust on the floor and let men sleep there. In the morning, he'd wake his homeless guests, serve them breakfast with a shot of whiskey and turn them out for the day.

Eventually, some hotels and boardinghouses were built, a newspaper was started and the town grew to include a bank, stores, a Methodist church and two ladies' clubs. Soon Eldora had over three hundred new buildings, eleven saloons catering to the miners' thirsts and several casinos to take their cash and gold dust. By 1898, at the height of the boom, six to eight stages crammed full of passengers arrived daily, swelling the population to 1,500. The Fourth of July 1898 was marked with hard rock drilling contests between miners from Ward, Central City and Gold Hill and topped off with a huge supper and all-night dancing. By 1901, children attended the two-story schoolhouse, and citizens were proud of their twenty-piece silver coronet band, which played at local events and celebrations.

As more mines were developed on Spencer Mountain, the rich surface deposits were exhausted, and miners had to dig deeper. They found more

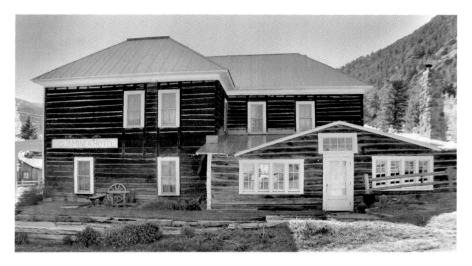

Eldora's citizens contributed money in 1934, during the Depression, to build the "social room" on the east side of the hotel.

complex gold ore that was locked into sulfides and tellurium, difficult and very expensive to extract. Neil Bailey, president of the Bank of Eldora, built a large ore reduction plant using a chlorination process that handled seventy-five tons of ore daily. The process was costly, and much of the valuable gold ore was lost during treatment. Bailey's Mill was an expensive failure.

As he lost money, Bailey's employees endured several "payless paydays," and in November 1899, a furious mob set the banker's house on fire. As he attempted to put out the flames, someone shot him in the arm. The wound became infected, and less than a week later, Neil Bailey died. The agitators were arrested, charged with murder and lodged in the Boulder jail, awaiting trial. They were quickly bailed out with money raised by Eldora's citizens. The trial took place in April 1901, and after due deliberation, the jury's verdict was, "for each and every defendant, Not Guilty." This tragedy marked the beginning of Eldora's economic decline. Other men tried to operate Bailey's mill using alternative extraction methods but were unsuccessful, and the mill was torn down for salvage. One by one, Eldora's mines shut down, businesses closed, the Monte Carlo girls left town and only one saloon was operating.

Some optimists had developed plans to build a rail line over the Continental Divide, and track had been laid almost to Eldora. On Christmas 1904, about one hundred dignitaries rode the train to the end

of the tracks and then walked through the snow to the Gold Miner Hotel to celebrate over a festive turkey dinner. Unfortunately for these dreamers, by 1905, Eldora remained the end of the line, and their grand plans for a railroad through the Continental Divide were abandoned.

With the decline of mining, land speculation around Eldora became big business. Always looking for a quick buck, speculators ran inflated newspaper ads and articles exaggerating the productivity of Eldora's defunct gold mines. Reminiscent of the scams of the town's early days, crooked promoters salted old mines, and once again, the gullible bought these low-grade properties.

In the spring of 1905, tourists arrived on the first wildflower special. The trains wound up the mountains, stopping at especially pretty meadows along the way, letting passengers pick armloads of colorful wild flowers. Summer brought students from Boulder eager to climb South Arapaho Peak and camp in the woods. Tourists marveled at Arapaho Glacier and hiked or rode horses up to the high mountain lakes to fish. After the end of World War I, they began driving up the rough mountain roads in their new automobiles, decreasing the number of train travelers. Then, a flood washed out the tracks, and the railroad didn't rebuild.

By 1925, Eldora's year-round population had shrunk to 17, but in the summer, it swelled to around 3,500. Visitors came to enjoy the scenery and a quiet summer in the cooler mountains, renting miners' old cabins or building small seasonal places. Many cabins and summer homes had quaint names, and the persistent *Eldora Echo* filled its pages with news items like "the Henry Fox Family is staying at the Wolverine," while the "J. Paul Leonard Family was at Rest-a-While," and the "Wee Hoose" and "Cloudland" always had summer guests.

In 1961, a group of businessmen purchased a four-hundred-acre parcel of land from the National Forest Service and organized and built a ski area and lodge. The new Eldora Mountain Ski Resort became the closest ski area for folks from Denver and Boulder. Over the years, the number of runs and lifts has been expanded, and lighting has been improved. Its first chair lift, Little Hawk, is the oldest operating one in Colorado, and the Eldora Historic District was listed on the National Register of Historic Places in 1989.

Gold Miner Hotel

The Norwegian carpenter who built the Gold Miner Hotel for the Randall brothers built it to last—and it has. He carefully dovetailed hand-hewn logs together, and his expert craftsmanship has lasted since the hotel opened for business in 1898. The logs were covered with white clapboard, and there was a comfortable, wide front porch. The thirty sleeping rooms in the two-story building rented quickly, and tenants enjoyed three meals a day. The manager was an excellent cook, and the dining room was always crowded.

As Eldora grew, the Gold Miner became a popular place for lavish dinner dances of fraternal organizations and social clubs, and the town's ladies often gathered here to play cards and enjoy magic shows. Sunday afternoons were filled with musical serenades and mandolin and violin concerts. The Gold Miner was the first establishment in town to receive a liquor license, and that same year, the hotel was sold to Charles Caryl of Denver for $2,500.

Caryl speculated in mining properties instead of tending to the hotel business. Then, he borrowed money from a wealthy older lady to invent a cure-all patent medicine. Next, he became engrossed in developing a utopian community, which failed. An investor in his patent medicine sued him, and his assets were tied up. As mining declined, property values fell and the hotel lost half its value, assessed at less than $1,000 in 1900. Caryl leased the hotel to his manager, who operated it until 1904.

Then, the management was taken over by Ma Martin, who'd come to Eldora with her three sons in 1898 after divorcing her husband. A plump lady with a decidedly sharp tongue, Ma often erupted with colorful language, and she had an aversion to tourists—even though their patronage was important to her business. She often snorted, "Some more of God's mistakes; comin' in camp with a dirty shirt an' a dollar bill; and they won't change either all the time they're here."

Ma Martin and her sons were well liked, and one grew up to become mayor. Once again, the hotel's cheerful parlor was the favorite gathering place, where town-folk spent hours singing songs and telling stories around the piano. Ma organized every dance or celebration on the town calendar, and the *Eldora Record* raved, "Mrs. Martin makes her hotel home-like and cheerful for her guests, and her table is the best in the mountain hotels." The reporter added, "Traveling men and visiting tourists and mining men will find this the place to stay when they come to Eldora." In 1904, the rates were two dollars a day with meals.

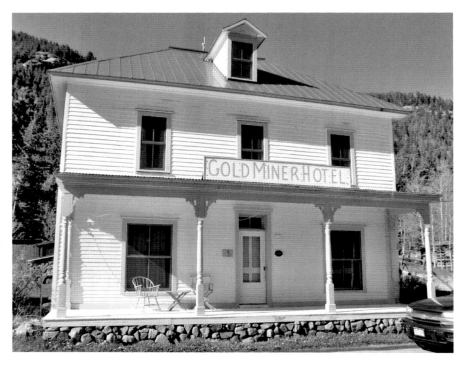

Built in 1897 by a Norwegian carpenter, the hotel looks much as it did then, with white clapboard over logs.

The Gold Miner Hotel was placed on the National Register of Historic Places in 1997.

Despite Ma Martin's efficient management, owner Caryl still neglected his hotel, didn't take care of his debts, and the place went into foreclosure. Caryl redeemed it for twenty-four dollars, but property values had decreased once again, and he sold the hotel for a ten-dollar gold piece. Ma Martin managed the Gold Miner into the 1920s but eventually moved to Denver.

Tourists continued to come to the mountains until the Depression put a damper on travel, and only a few rooms were rented during the summers. In 1934, the townspeople contributed money to build a "social room" on the east side of the hotel. Dues were paid for its operation, and the room was used for weddings, dances, meetings and luncheons. There were educational programs and social gatherings, and people got together to play cards, sew and catch up on the news. Every week, a physician from Nederland held a clinic here, and at Christmas, hotel owner Fred Anderson played Santa Clause at the town's annual Christmas party.

The current owners bought the Gold Miner in 1986. They have restored it as close to its original state as possible with five larger bedrooms, a lobby, a farm kitchen and the social room. In 1997, it became a Boulder County Landmark and was listed on the National Register of Historic Places.

In 2005, a steel framework was added in the ceiling of the social room to protect the roof against a heavy snow load. This room is still used by the community, and of all the hotels in mining camps throughout this region, the Gold Miner is the only one that has survived and still welcomes guests.

Ghosts

For years, there have been whispers about the ghost that lives upstairs at the Gold Miner. Owners Carol Rinderknecht and Scott Bruntjen are always interested in learning if their guests have encountered their ghost. One woman announced at breakfast that she'd "felt a presence" in her room the night before. She was certain that it was watching her get ready for bed, and this made her nervous. Insisting that she needed her sleep, she lit some candles and then showed the spirit out of the room. She got a good night's rest.

The owners are usually present at the hotel when repairs are needed, but this wasn't possible when a plumber was called. They told him briefly about the ghost, but the plumber assured them he'd be fine. He added that since he didn't believe in ghosts, they couldn't scare him.

The couple was gone for several hours, and when they returned, the plumber was obviously relieved. He'd encountered some unexpected problems, which delayed the completion of the job. He'd gone downstairs, shut off the water, came back upstairs and found it still running. He went back downstairs and once again turned off the water. When he returned upstairs, the water was still on. The plumber repeated this scenario several times with the same result. Really exasperated and tired of running up and down the steps, he yelled loudly, "OK! I believe! Now let me finish this job and get out of here!" Once again, he shut off the water downstairs, and this time when he came back up, the water was not running. He was finishing the job when Carol and Scott returned. When he left, he told them, "Guess maybe there are some ghosts—at least around here."

Over the years, the Gold Miner has been owned or managed by strong, determined women. Are they still keeping an eye on the hotel, tied to it by timeless tasks and responsibilities? Everyone has an opinion, even the Nederland Historical Society, which wrote about the Gold Miner, "Some even say it's haunted by its characters of the past."

11
Estes Park

The little town of Estes Park was named after Joel Estes, who was the first to settle here in 1860. He'd found gold in California and joined the Pikes Peak Rush in 1859. He'd come west with his wife, twelve children, five slaves, horses, oxen and cattle. Estes settled on Cherry Creek, but his itchy feet soon took him to Golden and then Fort Lupton. While bear hunting in the mountains, Estes found a promontory overlooking a beautiful valley. He uprooted his family again to settle here. He raised cattle and built the first wagon road from the valley, using it to drive his stock to Denver.

William Byers, founder of the *Rocky Mountain News*, came to see the valley, which he named Estes Park in honor of its first settler. It wasn't long before Estes got itchy feet again, and after the unusually harsh winter of 1866, he sold or traded the entire valley and his cabin for fifty dollars and a team of oxen. He loaded his wife, Patsey, and now thirteen children into a wagon and headed back to Fort Lupton. The altitude and cold weather had been hard on Patsey, and Estes finally settled down near present-day Aztec, New Mexico. This became Joel's last home and where he died in 1875. He is buried in Farmington, New Mexico. The Estes cabin in Rocky Mountain National Park is listed on the National Register of Historic Places.

The beauty of the Estes Valley drew many visitors, and in 1872, the Earl of Dunraven tried to buy it all for his own private hunting preserve. Since he wasn't a citizen, he wasn't eligible to file for land under the 1862 Homestead Act. Dunraven hired Theodore Whyte to acquire property for him in what became one of Colorado's biggest land swindles. Whyte hired

homeless drifters in Denver, and each man filed on 160 acres of land in Estes Park. Some claims were made by fictitious persons and people who'd never been in Estes Park, enabling the Earl to accumulate 15,000 acres. Valley settlers contested his claims, exposing the fraud, and their legal challenges eventually reduced Dunraven's holdings by half.

The earl was impressed by the number of hikers, mountain climbers and tourists visiting the valley and decided to put some of his land to a more acceptable use by opening the Estes Park Hotel. The valley's first, it was quickly nicknamed the "English Hotel," and artist Alfred Bierstadt's painting of Long's Peak was created on the hotel's veranda. The painting publicized this area's beauty, and it hung in the capitol rotunda for years.

Isabella Bird, a widely traveled English woman, arrived in 1873. The first female member of the Royal Geographic Society, she was guided around Estes Park by Rocky Mountain Jim Nugent. A romance developed between the spunky lady and the colorful mountain man, who'd lost an eye in a battle with a grizzly bear. Isabella eventually returned to her

The Stanley Steamer auto, invented by Freelan and Francis Stanley.

The Stanley Hotel overlooks the valley and Estes Park.

world travels and wrote *A Lady's Life in the Rocky Mountains*, which contained glowing descriptions of the mountains and handsome Jim.

The number of guest ranches and lodges increased dramatically over the years, and by 1903, F.O. Stanley had given a boost to tourism by improving the roads into Estes Park and building the hydroelectric plant on Fall River. It supplied electricity to his new hotel and the village of Estes Park. Then, Stanley donated money toward building a city sewer system. By 1908, the population was about eight hundred, and a water company provided fresh water piped from the mountains.

When Enos Mills proposed the establishment of Rocky Mountain National Park to protect the area, Stanley, the Denver Chamber of Commerce and the Colorado Mountain Club supported his idea. The bill was introduced in both houses of Congress in February 1913, despite the opposition of logging, grazing, mining and irrigation interests.

For the next two years, Enos Mills made numerous speeches, wrote articles and worked vigorously to gain support for the national park. The *Denver Post*, the Colorado Chamber of Commerce, the Colorado General Assembly, the state's Democratic Party and Colorado's state senators and representatives brought enormous political pressure to bear, and the Senate

passed the bill in October 1914. The House approved it in January 1915, and President Wilson signed the bill that created Rocky Mountain National Park on January 26, 1915.

When the park was finally approved, there was a great deal of celebrating in Colorado, and months were spent planning the dedication of Rocky Mountain National Park. The ceremony—held on September 4, 1915, in Horseshoe Park—was the largest gathering of automobiles yet in Colorado. A century later, 2014 saw the national park and Estes Park have its greatest number of visitors, 3,434,754. The Centennial Celebration began in September 2014 and will last until September 2015.

Baldpate Inn

When you've spent seventy-five years in the place that you built with your own hands, it would be very hard to leave it all behind. That seems to be the case with the Maces, who are still keeping an eye on their Baldpate Inn. Gordon and Ethel Mace came to Estes Park on their honeymoon in 1911 and decided to make this beautiful place their home. They built a log cabin on the north slope of Twin Sisters Peak with its view of the valley, surrounded by jagged peaks and mountains. They added four cabins and were so successful at keeping them full that they decided to build an inn. Since their finances were limited, they used hand-hewn timber from their property and built massive stone fireplaces for heat. When the inn opened in 1917, it had hot and cold running water, indoor plumbing and electricity.

The Maces named their property Baldpate Inn after a popular mystery novel, *Seven Keys to Baldpate*. Following the story line, the Maces gave every guest their own unique souvenir key to the Baldpate Inn. When World War I broke out, the price of metal became so expensive that continuing the tradition was impossible. Instead, loyal guests who returned during wartime began bringing a key with them, and the competition to find unique keys became so fierce that the Maces decided to put the gift keys on display. This was the beginning of the world's largest collection of keys, now well over twenty thousand. There's a key from the Pentagon, several castles, the Queen Mary, Mozart's wine cellar, Westminster Abbey and even Frankenstein's Castle and Hitler's bomb shelter. The homemade keys are unusual, and there are several that were made from spoons around 1896 by inmates at the

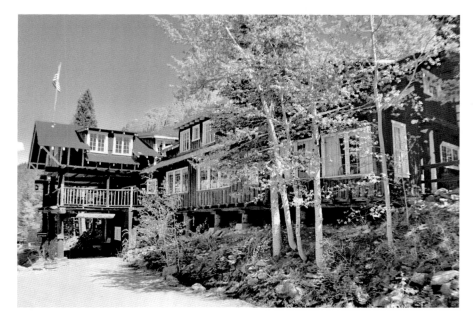

The Maces built the Baldpate Inn from timber on their property.

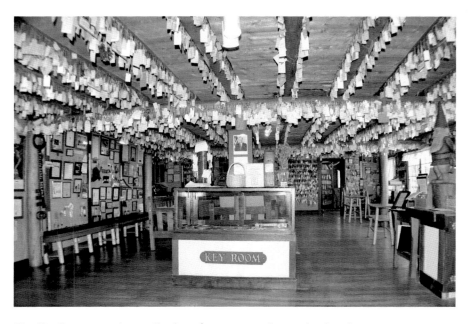

The Key Room contains a collection of over twenty thousand unique keys.

Colorado Territorial Prison. Recently, owner Lois Smith added the key to Lord Dunraven's Estes Park Hotel to the collection.

The dining room contains a large collection of autographed historic photographs that were taken by Charles and Stuart Mace, Gordon's brothers, who were both professional photographers. Some famous names that have stepped through the inn's front door are Betty Grable, Gregory Peck and Jack Dempsey. The Maces operated the Baldpate Inn until 1986, when it was purchased by the Smith family, who have owned it for nearly thirty years. They are only the second family to have owned the old inn.

The inn was listed on the National Register of Historic Places in 1996, and it has been welcoming guests for over a century. A stay at the Baldpate today is much like a stay one hundred years ago—although the original wooden floors of this rustic mountain lodge probably creak and groan more than they did back in 1917. Visitors still get acquainted around the rock fireplaces, whose warmth is welcome on chilly mountain evenings. There are plenty of claw-foot tubs for soaking after a day hiking in the park. The rainbow colors of the hummingbirds flocking to the numerous feeders just might keep you on the sun porch, getting your exercise in a rocking chair.

Ghosts

Psychic Suzanne Jauchius visited the inn, and while looking at the huge collection of keys in the Key Room, she peeked into an adjacent room. She saw a gray-haired woman sitting in a wingback rocking chair in front of a small fireplace. She had her feet tucked up on an ottoman and was reading the Bible. Suzanne said the woman was wearing a high-collared dress and described her as a "grandmotherly type." The old woman just faded away right in front of the psychic.

Intrigued, Suzanne returned to the inn the following day and talked to a longtime employee about this experience. He'd seen the apparition of the woman several times and showed the psychic an old family photograph album in the Key Room. He'd just picked it up when a gust of wind blew through the room. Suzanne said, "It wasn't just a light breeze, and it wasn't a draft—it was a wind. It blew one young lady's dress up, and it slammed the French doors shut. There were no windows open." When the wind passed, Suzanne looked through the photo album, which contained many pictures of that same woman. "Well, that's Grandma," the employee told her.

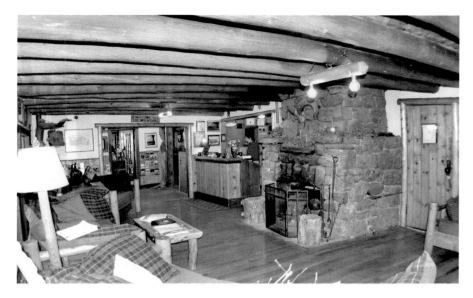

Guests can relax around the lobby's fireplace on cool evenings.

Former owner Leeann Mace took a small group of visitors, including Suzanne, upstairs to see Grandma's room. As they neared it, a strong wind once again slammed a bedroom door shut and blew another one open. Suzanne said later, "It was one of the few places I've been where a phenomenon actually presented itself…It was like Grandma wanted us to know she was there." While taking pictures in this room, our new camera batteries were completely drained—twice.

Leann shared stories about Grandpa Gordon Mace, who strongly disapproved of smoking. The inn's guests must smoke outside, but there's still a lot of interference with their habit. Cigarettes disappear, even whole packs are found smashed with the cigarettes broken into pieces. Sometimes a guest lights up, and when he puts his cigarette in an ashtray, it's stubbed out by an invisible hand. Matches and lighters are frequently misplaced or disappear completely.

Grandpa disapproves of alcohol, too. Occasionally, someone may order a drink and set it down. Then when they reach for it, the drink is gone. Cocktails are mysteriously spilled or swept off counters and coffee tables, inconveniencing the drinker. Leeann said, "That was Grandpa, again!" She believes both Grandma and Grandpa are still around, keeping an eye on the Baldpate Inn.

The caretaker, Paul Hamilton, always ignored talk of ghosts. However, he said, "Some nights when nobody was at the inn except me and my dog, I'd hear somebody running up and down those stairs. I just cast it off as being the wind or something like that."

Stanley Hotel

Freelan Stanley, "F.O.," was probably huffing and puffing like his Stanley Steamer auto when he drove into tiny Estes Park. The doctor back east had predicted the fifty-three-year-old, one-hundred-pound man would be dead within three months, so he'd come to Colorado, hoping to prove the medico wrong. And he did! The high, dry air of the Rocky Mountains helped cure his advanced case of tuberculosis.

Stanley bought land and selected a hillside overlooking the Estes Valley as the site for a fine hotel. Money wasn't a problem because F.O. and his twin brother, Francis, had made a fortune when they sold their process for coating photographic plates to Eastman Kodak. Then, he and Francis designed the Stanley Steamer automobile. F.O. built a hydroelectric plant on Fall River to supply electricity to the hotel and the entire town. Estes Park had electric power even before New York City.

The four-story, Georgian Revival hotel of white clapboard had a long central gallery where guests chatted and rocked, taking in the huge views of Long's Peak, the valley and surrounding mountains. The spacious lobby in the center was light and airy, and a grand staircase was flanked on each side by large stone fireplaces. The west wing's formal dining room had large windows, framing the valley and mountains. The brass 1909 Otis elevator in the lobby was operated hydraulically and then converted to an electrical cable mechanism in 1915.

The guest rooms were furnished with fine mahogany and cherry wood furniture and plush carpeting. The rooms had telephones, modern bathrooms and four-poster or brass beds. Stanley took a personal interest in all aspects of his hotel, and his pride was his all-electric kitchen, one of the first in the nation.

Brochures were designed to attract easterners who could afford to spend the season or at least six weeks of elegant leisure in the Colorado mountains. There was a bowling alley, croquet and tennis courts, a golf course and plenty of evening activities. Guests would dance the night away

The Stanley's gala opening was on July 4, 1909.

"to a high-class orchestra" and participate in amateur theatrical events and musical evenings. A swimming pool and landing field were planned.

The first guests arrived on June 22, 1909, for a pharmacy convention, and the grand opening was a formal affair on July Fourth. Guests toured the hotel, sipped cocktails in the lobby and enjoyed an elegant dinner in the dining room. Everyone pronounced the Stanley the finest hotel in the mountains.

F.O. ushered in the golden age of auto touring, and a 1906 Stanley Steamer ten-horsepower Runabout sits proudly in the lobby. His fleet of Steamer Mountain Wagons carried passengers from the train depots and soon transported royalty, rich tycoons, famous movie stars and celebrities. The hotel's guest register is impressive, headed by President Teddy Roosevelt, followed by Harvey Firestone; J.C. Penney; Drs. William Mayo and Jonas Salk; the *Titanic*'s Unsinkable Molly Brown; musicians John P. Sousa, Lawrence Welk, Johnny Cash and Bob Dylan; evangelist Billy Graham; news commentator Lowell Thomas; and opera singers Marian Anderson, Lily Pons and Enrico Caruso.

Flora Stanley's Steinway concert piano, given to her by F.O. on opening day, is in the Music Room. In the afternoon, there was chamber music, and Flora often played for the guests. John Philip Sousa always tuned her

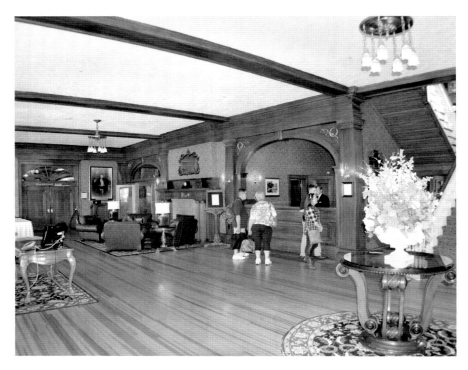

Many famous guests have registered here, and John Philip Sousa always tuned Flora Stanley's Steinway concert piano.

piano on his visit. Joan Baez and opera stars Enrico Caruso and Lily Pons all played it. The gentlemen enjoyed cards and billiards or gambled in the Casino nearby. The Manor House next door was a miniature version of the hotel and had thirty-three winterized rooms. The Concert Hall and Casino hosted large concerts, conventions and dinner theater.

In 1926, Stanley sold the hotel complex, beginning a long succession of owners. The hotel closed during World War II, and in 1976, major restorations were made and a heating system installed so the hotel could operate during the winter. In 1977, the hotel and all the buildings on the thirty-five-acre complex were placed on the National Register of Historic Places. In 1985, it became part of a National Historic District, and ten years later, it was purchased through the bankruptcy court by the Grand Heritage Hotels for $3.1 million. Extensive renovations have been done to restore the hotel's comfortable elegance.

Stephen King developed his idea for *The Shining* during the winter of 1975, patterning the Overlook Hotel in his novel after the Stanley. The 1980

movie with Jack Nicholson wasn't made here because of its deep snow, but in 1996, the television mini-series was filmed at the hotel.

F.O. Stanley was a major force in bringing tourists to Estes Park, supporting the proposal for a national park, improving roads, providing electricity to the town and financing its sewer system. This earned him the title of "Grandfather of Estes Park."

Ghosts

The Stanley is one of the Top Ten Most Haunted Places in America—with good reason. There are enough ghost stories and paranormal encounters here to fill several books. There have been so many strange events throughout the hotel that it's easy to conclude that the entire place is haunted by a number of ghosts. Unlike some hotels that don't talk about their ghostly guests and eternal employees, the Stanley acknowledges their presence. The hotel's popular ghost tours offer numerous accounts of the ways these mysterious entities make their presence known. The history of the Stanley comes alive as tour groups explore it from attic to basement.

Room 217 is associated with Stephen King and *The Shining*, but other well-known people slept here, including Teddy Roosevelt, Molly Brown, Emperor Hirohito of Japan and Jim Carey when he was filming *Dumb and Dumber*. In June 1911, the all-electric hotel had a power outage, and its wall lamps switched to gas. When Elizabeth Wilson, a housekeeper, attempted to light a lamp, the gas ignited and blew her through the floor into the ballroom below. Miraculously, Elizabeth only broke both ankles. Stanley took care of Elizabeth's medical expenses and insisted she stay at the hotel while her injuries healed. Her job was held, and she remained a loyal employee until she died in 1951 at the age of ninety. There are many stories about Wilson, who might unpack your luggage and hang the clothes neatly, as she did for King. Occasionally, she tosses things about. Many guests have difficulty taking photos here because a horizontal purple bar appears in their digital camera viewfinder. This happens no matter where they stand in room 217. The bathroom faucets turn on and off by themselves, and the door opens and closes frequently.

One man in 217 was awakened when he felt his wife crawling out of bed. She stood looking out the window and asked him to come see the family of elk outside. He stared at her for a long time—because his wife had been dead for five years! Guests have caught glimpses of a woman in old-fashioned

clothing around room 217. When one ghost tour group entered the room, everyone started taking pictures, and a woman even sat on the bed to have her photo taken where Stephen King slept. She left an impression in the bedspread, and as one man watched, the spread was given light tugs by unseen hands until the indentation was pulled straight. Then, the leaves of a fern near the bed moved gently as if someone brushed by. The bathroom door suddenly slammed shut, startling everyone.

There have been many strange occurrences in the MacGregor Ballroom, where the light fixtures sometimes revolve or turn on and off by themselves. Phantom parties in the ballroom, the sound of voices, music and laughter have been heard as well.

One night after a Halloween party in the ballroom, three late-shift chefs were cleaning the kitchen when one disappeared for a few minutes. He returned, looking puzzled, and said he'd heard music coming from the ballroom. No one was there. Then, a second chef thought he'd heard music, but when he opened the door, the sound stopped and the ballroom was empty. The desk clerk denied playing a radio, and after the third chef checked the room, they were certain something strange was happening. Anxious to leave, they checked the ovens, which had been turned off earlier, only to find them all on again. Then, a rack of dishes crashed loudly to the floor when no one was near. That did it—the three men rushed out of the kitchen.

F.O. Stanley is usually seen in the lobby or the Billiard Room, where he spent many hours. His reflection has been glimpsed in an antique mirror, and the sound of men's voices and billiard balls clinking together are often heard. Stanley enjoyed having the ladies watch the games, seated comfortably on the padded benches around the room. An older woman in a blue dress has been seen here several times, usually surrounded by lavender fragrance. A frightened housekeeper once encountered her and rushed to report seeing a ghost. She said the lady had "looked right through" her and then vanished.

The Pinion Room was the gentlemen's smoking room, and the odor of tobacco and cigar smoke is often noticed. Occasionally, the chimney belches out clouds of black smoke when there's no fire, and the electric lights flash erratically.

Clerks at the front desk have seen the rattan chairs quietly rocking on the front porch when there's no breeze and no one is sitting in them. Mr. Stanley's large wooden rocker, his favorite, often moves slowly back and forth. Several desk clerks have looked up to see tall, well-dressed F.O. watching them, and then he vanishes. One man approached the front desk to register and was greeted by a woman in a long dress with a high lace collar. Her hair was

piled on top of her head and secured with an elaborate butterfly clip. As she welcomed him, another desk clerk appeared and welcomed the man as the lady just faded from sight. The guest said ruefully, "I just couldn't tell this guy I'd seen a lady fade into the cubbyholes."

Flora Stanley's spirit appears often, usually in the Music Room and the lobby, accompanied by a rose fragrance. Sometimes music is heard there as the piano keys move through an old melody. When someone enters the room, everything stops. Flora gradually lost her sight, but she played her beloved piano until she died in 1939 at ninety-two. F.O. died a year later. Recently, a man wrote to the hotel about his experience of seeing a young woman playing the piano. He said when he approached, she was suddenly transformed into an elderly woman, and then she disappeared.

In 2004, a photographer took an unusual photograph of an ectoplasm form, which is a vaporous substance. His photo showed a form that resembled a woman sitting at the piano with a small, vaporous shape standing nearby watching. This photo was taken during a period of unusual activity in the Music Room.

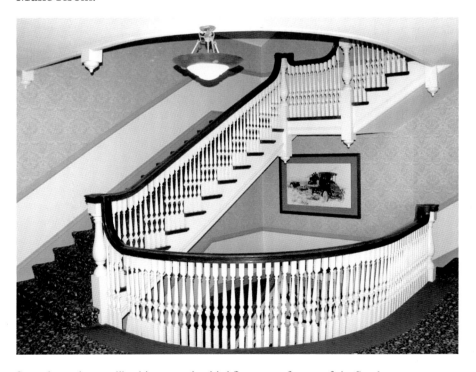

Sweeping staircases, like this one to the third floor, are a feature of the Stanley.

The fourth floor was home to employees, the private staff of visiting families and their children. They spent the day playing with their nannies, and the sounds of children running and laughing, balls bouncing and jacks being thrown are often heard. Mary Orton, or "Scary Mary," a ghost tour guide, is very familiar with the "spirit children" on the fourth floor. Mary is quick to point out that she has no special powers, but mediums and clairvoyants have told her that young spirits gather around her. Mary says sometimes the smaller children hide behind her long skirts. As she stood in the hall, several people in our tour group saw her skirts move as if a small person really was peeking out.

The couch in the fourth-floor hallway is a favorite spot for the spirit children, and guests often leave candy and treats. Mary says the spirit children relate more easily to youngsters, who are more open and receptive. While standing near this couch, a twelve-year-old girl in a tour group was certain there was a light touch on her hair and dress. Numerous photos were taken showing orbs of all sizes around her.

Lord Dunraven, the colorful character whose portrait is displayed near the MacGregor Room, hangs out on the fourth floor. The fragrance of his favorite cherry tobacco smoke often announces his presence. The earl was a notorious womanizer, and this is where ladies are most likely to get their bottoms patted or pinched. Since the earl kept his eye out for money and glittery stuff, too, jewelry is frequently moved about or misplaced.

Room 401 was originally the nannies' lounge, and it's frequently booked as the bridal suite. One couple noticed the cherry tobacco aroma in their room, and both saw the shadowy figure of a man standing in the corner. He was tall with just a ring of hair around his bald spot, and he faded from view as they watched. When they went downstairs, they were startled by the portrait of Lord Dunraven. "That's him! That's the man in our room!" they shouted. During their week's stay, they sensed the spirit's animosity toward the man, once sweeping his glasses off the nightstand. Then, something nastily pushed the husband's wedding ring down the drain as he washed his hands, necessitating a visit from the plumber.

The closet is spooky in room 401, and many people have seen a ghostly Lord Dunraven standing near it. Some have even felt a light touch when they opened the closet door, while others swear something blew cherry tobacco smoke right into their faces. Often, the door eases open slowly on its own and then slams shut. A teenager who was touring the hotel with her mother stepped into 401, and the door immediately slammed shut behind her. It stuck, and she wasn't able to open it to leave. Then the closet door swung

open, and something cold whispered in her ear. The terrified girl screamed and pounded on the door while someone ran downstairs for help. Suddenly room 401's door clicked open, and the girl dashed out. When the desk clerk checked the vacant room and closet, he found nothing.

Another couple wrote to the hotel after their stay in room 401, saying that the room felt "electrified," and that "their hair stood straight up on their arms." They'd obtained many high EVP readings and photos of orbs here and recorded children laughing and women talking. They even had sounds of tapped responses to their questions.

Jason Hawes, from the SyFy Channel's *Ghost Hunters*, spent the night in room 401. Members of the Atlantic Paranormal Society (TAPS) crew filmed the closet door opening slowly and a sudden shattering of a water glass on the nightstand by Jason's bed. TAPS was never able to debunk these incidents.

A shadowy image resembling Lord Dunraven has been spotted peeking out of room 407's window. White, wispy shapes flit past the window when the room is vacant, and occasionally, a figure is glimpsed standing in a corner near the bathroom door. One guest became so exasperated with a lamp in the corner of this room that kept turning off that he finally exclaimed, "I know you're there, and I'd appreciate your leaving the lamp alone." There were no further problems with the lamp, but there was plenty of noise throughout the night as the empty elevator ran up and down.

The Stanley was originally built to be open only during the summer months.

Room 418 has a lot of paranormal activity and is one of the most haunted. Numerous EVPs have been captured, and recordings have been made of a little girl's voice and people talking. The housekeeping staff doesn't like working here, and some are frightened when the TV flips on and off by itself. If the channel is changed, it immediately switches back to *The Shining*, which is carried on a continuous loop. Often, the made-up beds look like someone has laid down on them—when the room is vacant.

Jesse, a clerk at the hotel, spent the night in room 418 and brought a special light to entertain the spirit children. Entering the room, he announced, "Kids, I brought you something." Then, he set up the light and left for a while. Returning, he went to bed, turning out the gift light. Immediately, tapping began on the window, and then he felt something squeezing his arm. The pressure became more insistent, and the tapping continued. Finally, Jesse got up and turned on his special gift light, saying, "Now let me get to sleep!" The tapping stopped, as did the arm squeezing. Others have reported a strange tapping on the window when there's no wind or tree branches nearby.

One couple decided to take the elevator to the upper floors, and when the doors opened, there was a little girl in an old-fashioned ruffled dress looking at them. Startled, they just stood looking back as the doors started to close. The man grabbed the door, and when it reopened, the little girl had vanished. Many people have seen this small girl standing in the elevator, just catching a quick glimpse as the door opens or closes. Some have just seen her reflection in the mirrored interior, and there's an abundance of stories about the elevator operating on its own, moving floor to floor with no passengers.

One winter, a transient woman pried open a basement window of the Concert Hall and crawled in to escape a snowstorm. She was found dead, and her death was attributed to cold and exposure. Psychics and paranormal researchers, including *Ghost Hunters* of TAPS, say something is definitely haunting the Concert Hall's basement. Mysterious footsteps, slamming doors and the sounds of furniture moving have been recorded. During one investigation, a flashlight was placed on the floor, and the spirit called Lucy was asked to turn it on. The flashlight went on. When asked to turn it off, the light went off. This exercise was repeated several times. When the investigators asked for audible evidence that someone was with them, a scraping sound came from a metal strip across the doorsill, as though a foot was dragging across it.

The Manor House is a replica of the larger hotel with its amenities and its own complement of ghosts. Full-body apparitions have been seen, and often, the Lady in Green, a pretty woman in a short green dress, appears.

The numerous photos of distinct images in windows and mirrors have made believers out of skeptics, and many people have seen the lights blazing in the Manor House as dancing figures waltz past the windows. The night air is filled with laughter and music, but if you approach a window or tiptoe toward the door, everything stops, leaving only silence and moonlight.

Elkhorn Lodge

The Elkhorn Lodge is the oldest continuously operating lodge in the Rocky Mountain region. It was built by William James, a merchant who'd come to hunt and fish. He fell in love with the area and wired his wife back in New York to sell their general store and house, pack up their three sons and come to Colorado. They settled in a valley near Fall River in 1876, built a rambling farmhouse and opened a guest ranch a year later.

Fishing in Fall River yielded "bushels of trout," and the James family took advantage of this bounty, supplying Denver restaurants with five hundred to eight hundred fresh Rocky Mountain trout per day. Their place became so popular that they added three wings to the farmhouse and built cabins that are still in use today. They named it Elkhorn Lodge.

During the 1890s, the dining room, which seated over two hundred, was always full, and guests raved over the venison steaks, fresh trout, raspberries, butter and cream. They added a candy kitchen, where the children had taffy-pulling parties while their parents played cards and billiards. James furnished the lodge with Stickley furniture, and many original pieces remain. The Stickley Museum has expressed an interest in purchasing some of these fine pieces for its collection. The lodge charged between nine and twelve dollars a week, meals included. Many vacationers came for a month, but others spent the entire season, from May to early September. The lodge was usually full, and when there were a few extra guests, tents were set up in the meadow. It was popular with avid fishermen like Paul Nitze, secretary of the navy under President Johnson; Otis Skinner, the actor; and Augustus Busch, the St. Louis beer baron.

When the trout population in Fall River declined due to the heavy fishing, James started Colorado's second fish hatchery in his private trout pond. The Estes Park Protective and Improvement Association took over the hatchery in 1907 and moved it to Fall River, where it operated until damaged by the Lawn Lake Flood in 1982.

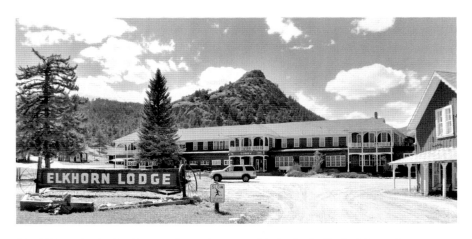

The Elkhorn Lodge is oldest continuously operated lodge in the Rocky Mountains.

There are several firsts at Elkhorn Lodge: it's the site of Estes Park's first schoolhouse, the first chapel, the first golf course and the first ice house. During the winter, large blocks of ice were cut from Fall River and hauled by the wagonload to the icehouse. They were packed in sawdust and stored for summer use.

Horseback riding was a favorite activity, and the big red barn was full of agreeable saddle horses that rented for one dollar a week. Guests often rode to Oldman Mountain, a sacred Native American vision quest site, or took all-day rides into Horseshoe Basin.

Much of the success of the Elkhorn Lodge was due to the gentlemanly ways and kindly disposition of William James. He presided over evening bonfires in the meadow as guests sang songs, told stories and recited poetry. James entertained everyone with his tales of ghosts and mountain men.

Ella and her two sons took over the operation when William James died in 1895. Howard James was known as the best fisherman in the valley and once invited 140 guests to a fish fry—and then set out to catch the fish. He had more than enough within a few hours—just as his guests arrived! Like his dad, Howard enjoyed entertaining and put on a show, flipping fresh trout in big cast-iron skillets over an open fire. Howard died in 1928, and his son took over the lodge.

The Elkhorn Lodge was operated by the James family for over eighty years until Howard Jr. sold it in 1961 to a group of Nebraska businessmen. There are about thirty-seven historic buildings on sixty-five acres, and

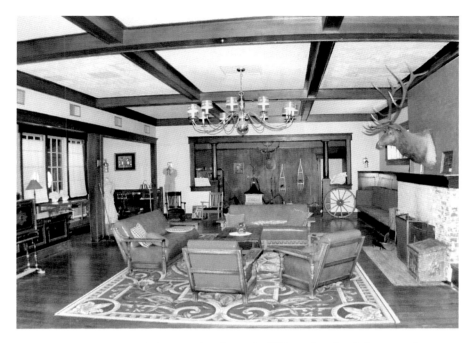

Guests enjoyed lodging and three meals a day at the Elkhorn for nine dollars a week.

it was listed on the National Register of Historic Places in 1978. It is still in operation, the longest continuously operated lodge in Colorado. It was named by Colorado Preservation as one of the top six most endangered places in the state. Renovations are now underway.

Ghosts

Everyone knows Eleanor James haunts the old lodge that she managed for years after her father died. If her rocking chair is moved from its spot, objects start flying through the air.

Jerry Zahourek, who bought the hotel in 1990, said that while two ladies were taking an afternoon nap in their lodge room, they both were awakened by "something ruffling" their hair. Their window was closed, and there were no obvious drafts, but both ladies "felt a presence in the room."

Early one morning when Jerry was making his rounds, he checked a portable gas heater that had been used in the dining room the previous evening. The stove's pilot light was off, and the stovetop was bare. As he

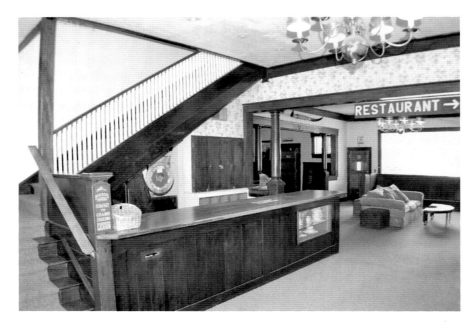

The sitting area in the lobby at the lodge, which was built around 1876.

continued his rounds, he noticed a scorched smell, like something burning. Worried about old wiring, he returned to the dining room, where a pile of rubber mats was now stacked on top of the heater. Although the pilot was still off, the mats were smoking and hot. After quickly eliminating the chance of a fire, Jerry hoped this was just a "ghostly" prank.

An employee named Sam Hackett snapped some photos of the tipis behind the bunkhouse. When the film was developed, there was a transparent image of a man in a western vest and jeans, holding a whip, standing in front of a tipi. Another employee said he looked like an old photo of a stage driver who brought tourists from Denver. He had a reputation of being mean and nasty, and everyone avoided him.

While they were the only guests staying in the lodge, one family noticed the sound of water running in the room next door. This went on for about thirty minutes, and they finally decided to check it out. The room wasn't locked, and there were no signs of an occupant, but the water was running steadily in the bathtub. After turning it off, they checked with the clerk who couldn't explain the incident but said, "Strange things happen here."

Altitude Paranormal investigated the paranormal activity at the Elkhorn Lodge in October 2013, and the group's videos can be seen

on the Internet. A child's voice can be heard answering some questions through a spirit box in the old schoolhouse and a church cabin.

The Rocky Mountain Paranormal Research Society combined its investigation with the ghost hunters of TAPS and spent some very cold hours in the stables and lodge. The two groups were equipped with every type of ghost-detecting equipment, and they picked up a sudden temperature drop in the dining room. Since it was a cold October night in 2013, they thought this might be due to the weather. They saw a shadowy image, which has been noted before, and picked up plenty of taps, creaks and groans in the lodge and stables.

12
GREELEY

In 1862, some immigrants to the Colorado Territory were interested in finding good farmland instead of gold. They scratched out a living in the dry dirt along the base of the Front Range, but it became obvious that irrigation was necessary before crops would grow. This led to the development of agricultural colonies, the members of which shared the cost of developing water projects. Most of the colonies were organized in the East, and it was essential that the members had enough money to buy certificates that entitled them to a city lot or farmland. Members were also expected to contribute toward the colony's costs of developing their new community.

One of the first was the Union Colony, organized in 1869 by Nathan Meeker, a reporter on Horace Greeley's newspaper, the *New York Tribune*. Greeley was treasurer, and Meeker served as president of this utopian community that was based on religion, temperance, education, agriculture and family values. They selected a seventy-two-thousand-acre site in Colorado Territory at the confluence of the South Platte and Cache la Poudre Rivers, near the Overland Trail.

The town was named after Horace Greeley and laid out on a grid, with Lincoln Park in the center, surrounded by commercial and government buildings. The streets were wide and lined with newly planted trees. Building with adobe bricks was encouraged to decrease the danger of fires, and within a short time, Greeley had several fine Victorian homes. After just one year, there were over four hundred houses, a colony hall, two brick

business blocks, a library, schools, churches, a concert/lecture hall and 1,500 residents. Greeley had no saloons, liquor stores or billiard halls.

The first large irrigation canal was built from the Cache la Poudre River, and a second canal was finished in 1871 to carry water twenty-seven miles to irrigate twenty-five thousand acres. Greeley's success inspired the establishment of the agricultural colonies of Loveland, Longmont, Evans and Platteville, bringing hundreds of additional colonists to the Colorado Territory. When the military post near Laporte was abandoned in 1872, the site was taken over by the Fort Collins Agricultural Colony, which offered memberships to persons "of good moral character."

The Kansas Pacific Railroad arrived in 1871, providing rail cars to take agricultural products to market. With the development of additional irrigation projects, the South Platte Basin was transformed into a vast network of ditches, canals and irrigated fields. Greeley had telephones by

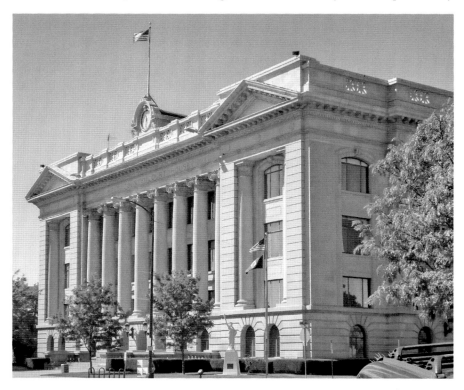

Weld County Courthouse in Greeley, which is the twelfth-largest city in Colorado. *Weld County Historical Society.*

1883, and downtown was lit by electric lights. Although prohibition came to Colorado in 1916, liquor was never allowed in Greeley until 1969, when voters approved alcohol sales by a narrow margin. The population continued to grow, and today, Greeley is the twelfth-largest city in Colorado and the Weld County seat.

Clarion/Ramkota Hotel

Sometimes ghosts remain in a place that was important in their lives even though the haunted building may be gone. The spirit hangs around the site, and it might affect the new building. The Clarion Hotel, formerly the Ramkota Hotel, was built on land previously occupied by a movie theater.

The Electric Theater, built around 1901, showed the earliest silent films to excited audiences. It was destroyed by fire in 1908. Its place was taken by the Orpheum Theater, which hosted vaudeville shows in addition to movies. Again, fire destroyed the theater in 1910, but it was rebuilt and opened in 1911. The Greeley citizens enjoyed concerts by the Philharmonic Orchestra here.

The Orpheum was sold, and the new owner, Jim Lynch, changed the theater's name to the Rex. A handsome plaque with "Rex" inlaid in red was placed in the sidewalk at the front entrance. Lynch totally remodeled the theater, sparing no expense, and he even put in a floor that sloped down from the back to the stage. This was a first in Greeley, and crowds flocked to see *Frankenstein* and *Dr. Jekyll and Mr. Hyde*. With a double-feature ticket costing just twenty cents, business was brisk and an evening at the movies was an affordable treat for families and a popular choice for couples. The theater became Greeley's hot spot, the place to see Hollywood's scariest movies.

Around 1930, there was another fire in the theater, and after repairs were completed, Lynch sold the Rex. Its new owner covered the ornate façade with white stucco, and by 1934, the Rex had become the Chief. For years, the citizens of Greeley enjoyed double features and afternoon matinees here, but the advent of television brought the curtain down for the last time. The February 12, 1973 issue of the *Greeley Tribune* sadly announced the closing of the Chief Theater. It also wondered what would happen to the theater's ghost.

Ghosts

The first time anyone caught a glimpse of a ghost in the theater was the summer of 1970 when the manager's friend was sitting in the balcony. Something caught her eye, and turning, she saw an attractive woman with blond hair piled on top of her head. She was wearing a long-sleeved white blouse and a floor-length skirt. The two looked at each other for a few seconds, and then the attractive woman simply disappeared.

The balcony was eventually closed, but supplies were kept there in a storage closet. One night, the assistant manager went upstairs to get candy and popcorn for the snack bar. He said. "I got a funny feeling when I stepped inside the storage closet." He turned and, looking out, saw a woman walking across the front of the balcony. Grabbing his supplies, he dashed toward the stairs. When he looked over his shoulder, he saw the woman opening the overhead trap door into the attic. She looked directly at him as he rushed downstairs. He described her as about thirty years old with shoulder-length blond hair, wearing a long-sleeved blouse and a skirt that fell below her knees. He said she looked like an image from the 1940s. His description sounded like the blond lady his friend had seen in the balcony. Their descriptions were amazingly similar, and neither one had discussed the incidents. Neither man believed in ghosts, but they had plenty of questions about their experiences.

When a reporter from the *Greeley Tribune* interviewed people who'd once worked at the theater, she heard some interesting stories. One man, who was an usher and doorman during the 1930s, said there'd been plenty of "stories about a ghost floating around town." The theater had at least three fires, and sometime around 1945, a portion of the balcony collapsed, but there'd been no reports of murders. There was one death, that of an elderly gentleman who suffered a fatal heart attack in the 1960s while watching *The Night of the Living Dead*.

There were many strange sounds and noises heard in the theater when there were no customers and the building was closed. During the late 1970s, a psychic and a self-described "transmittal mind therapist" spent time in the building, and both concluded that a young woman with blond hair, possibly an actress, had been murdered in the theater by her lover. The two speculated that the victim might be buried in the building's basement or hidden somewhere behind its brick walls. When the theater was torn down, nothing of note was obvious in the basement.

There's another story about a woman who was thrown off the balcony and killed by the fall. Some people think this apparition might be Cora Rosa

Allyn, who was shot in her home on June 10, 1916. Since this murder took place just a few blocks from the theater, and the crime was never solved, there's speculation that her sad spirit wanders here.

The theater was eventually torn down, and the Ramkota was built on the site. Hotel guests have complained about the lights flickering or turning off unexpectedly. The television sets sometimes flip on and off by themselves, and guests' belongings are moved about and even disappear.

Several employees of the former Ramkota Hotel, now the Clarion, have seen the apparition of a woman they call "Rosie" on the third floor. The hotel's accountant and manager of the third-floor nightclub received a phone call from a terrified housekeeper, screaming that she'd "seen something in a room." The frightened employee ran out of the hotel and refused to return. Some of the hotel's maintenance workers and custodial staff won't work alone on the third floor and insist on keeping all the lights on while there. Another housekeeper said that she felt uneasy and "like someone is watching me."

Peggy Ford, a research coordinator at the Greeley Museum, once commented that the ghost that intrigued people in the town the most was that mysterious woman in the old Chief Theater. They wonder, "Is she still around?"

BIBLIOGRAPHY

Abbott, Carl, Stephen Leonard and David McComb. *Colorado: A History of the Centennial State*. Niwot: University Press of Colorado, 1994.
Arps, Louisa. *Denver in Slices*. Athens, OH: Swallow Press, 1998.
Bird, Isabella. *A Lady's Life in the Rocky Mountains*. Norman: University of Oklahoma Press, 1960.
Bjorklund, Linda. *A Brief History of Fairplay*. Charleston, SC: The History Press, 2013.
Blair, Edwin. *Leadville: Colorado's Magic City*. Boulder, CO: Pruett Publishing, 1980.
Brockett, D.A. *Wicked Western Slope*. Charleston, SC: The History Press, 2012.
Brown, Roz, and Ann Leggett. *Haunted Boulder 2*. Boulder, CO: White Sand Lake Press, 2003.
Buys, Christian. *Historic Aspen: Rare Photographs Featuring the Journals of Charles Armstrong*. Ouray, CO: Western Reflections Press, 1980.
Clark, Alexandra. *Colorado's Historic Hotels*. Charleston, SC: The History Press, 2011.
Crain, Mary. *Evergreen, Colorado*. Boulder, CO: Pruett Publishing, 1969.
Dallas, Sandra. *No More than Five in a Bed*. Norman: University of Oklahoma Press, 1967.
Davis, Susan. *Stanley Ghost Stories*. Estes Park, CO: Stanley Museum, Inc., 2005.
Faulkner, Debra. *Ladies of the Brown*. Charleston, SC: The History Press, 2011.

Bibliography

Fleming, Kathy. *Apparition Manor*. Glenwood Springs, CO: Twin Aspen, 1995.

Goodstein, Phil. *The Ghosts of Capitol Hill*. Denver, CO: New Social Publications, 1996.

Griswold, Don, and Jan Griswold. *History of Leadville and Lake County*. Denver: University Press of Colorado, 1990.

Haffen, LeRoy, and Ann Haffen. *The Colorado Story*. Denver, CO: Old West Publishing, 1960.

Hansfors, Nancy. *Northern Colorado Ghost Stories*. Fort Collins, CO: Indian Hills Bookworks, 2005.

Hull, Christine. *Cobwebs and Crystal: Colorado's Grand Old Hotels*. Boulder, CO: Pruett Publishing, 1982.

Hunt, Corrine. *The Brown Palace: Denver's Grand Dame*. Denver, CO: Archtype Press, 2003.

———. *The Brown Palace Story*. Denver, CO: Rocky Mountain Writers Guild, 1992.

Kemp, Don. *Silver, Gold and Black Iron*. Denver, CO: Sage Books, 1960.

Kemp, Don, and John Langley. *Happy Valley, Promoters' Paradise: Historic Sketch of Eldora*. Boulder, CO: Smith-Brooks Printing Company, 1945.

Koelling, Janet. *Hotel Colorado: Fountains of Enchantment*. Glenwood Springs, CO: Hotel Colorado Nonprofit Museum Corporation, 2001.

Kreck, Dick. *Murder at the Brown Palace*. Golden, CO: Fulcrum Publishing, 2003.

Laskey, Celeste. *Ghost Stories of the Estes Valley*. Vol. 1. Loveland, CO: Write On Publications, 1998.

———. *More Ghost Stories of the Estes Valley*. Vol. 2. Loveland, CO: Write On Publications, 1999.

Lavender, David. *The Rockies*. New York: Harper & Row, 1968.

Leggett, Ann, and Jordan Leggett. *Ghosts of Boulder*. Charleston, SC: The History Press, 2013.

———. *A Haunted History of Denver's Croke-Patterson Mansion*. Charleston, SC: The History Press, 2011.

Leonard, Stephen, and Thomas Noel. *Denver: Mining Camp to Metropolis*. Niwot: University Press of Colorado, 1990.

Lommond, Carole. *Jefferson County, Colorado*. Golden, CO: Views Publishing, 2009.

McConnell, Virginia. *Bayou Salado: The Story of South Park*. Chicago: Sage Books Swallow Press, 1966.

Nelson, Jim. *Glenwood Springs: A Quick History*. Fort Collins, CO: First Light Publishing, 1998.

Bibliography

———. *Glenwood Springs: The History of a Rocky Mountain Resort*. Ouray, CO: Western Reflections, Incorporated, 1999.

Noel, Thomas. *Buildings of Colorado*. New York: Oxford University Press, 1997.

———. *The City and the Saloon: Denver, 1885–1996*. Boulder: University Press of Colorado, 1996.

———. *Colorado: A Liquid History and Tavern Guide to the Highest State*. Golden, CO: Fulcrum Publishing, 1999.

———. *Mile High City: An Illustrated History of Denver*. Denver, CO: Heritage Media Corporation, 1997.

Parkinson, Angela. *Hope and Hot Water: Glenwood Springs*. Glenwood Springs, CO: Glenwood Springs Legacy Publishing, 2000.

Pettem, Silvia. *Guide to Historic Western Boulder County*. Evergreen, CO: Cordillera Press, 1989.

———. *Inn and Around Nederland*. Longmont, CO: Tourism & Recreation Program of Boulder, 1998.

———. *Legend of a Landmark: A History of the Boulderado Hotel*. Missoula, MT: Pictoral Histories Publishing, 1986.

———. *Red Rocks to Riches*. Boulder, CO: West Publishing, 1980.

Pharris, Kevin. *Haunted Heart of Denver*. Charleston, SC: The History Press, 2011.

———. *Historic Haunts Around Denver*. Charleston, SC: The History Press, 2012.

Pierson, Francis. *Summit of Destiny*. Denver, CO: Charlotte Square Press, 2008.

Pittman, Rebecca. *The History and Haunting of the Stanley Hotel*. Dallas, TX: 23 House Publishing, 2011.

Pretti, Roger. *Between Heaven and Leadville*. Leadville, CO: Chicken Hill Publishing, 2012.

Rohrbough, Malcom. *Aspen: The History of a Silver Mining Town, 1879–1893*. New York: Oxford University Press, 1986.

Ruland, Sheila. *Lion of Redstone*. Boulder, CO: Johnson Publishing, 1981.

Rust, Mary. *Historic Hotels of the Rocky Mountains*. Niwot, CO: Roberts Rinehart Publishing, 1997.

Ubeloe, Carl, Maxine Benson and Duane Smith. *A Colorado History*. Boulder, CO: Pruett Publishing, 2001.

Urquhart, Lena. *Glenwood Springs: Spa in the Mountains*. Dallas, TX: Taylor Publishing, 1970.

Van Dusen, Linda. *Historic Tales of Park County*. Charleston, SC: The History Press, 2013.

Wallace, Elizabeth. *A Hidden History of Denver*. Charleston, SC: The History Press, 2011.

BIBLIOGRAPHY

Watson, Laurel. *Yampa Valley Sin Circuit*. Charleston, SC: The History Press, 2014.
Wiatrowski, Claude. *Railroads of Colorado*. St. Paul, MN: Voyageur Press, 2002.
Wommack, Linda. *Colorado's Landmark Hotels*. Palmer Lakes, CO: Filter Press, 2012.
Wood, Richard. *Here Lies Colorado*. Helena, MT: Far Country Press, 2005.

About the Author

Exploring adobe forts and Anasazi ruins in Arizona as a kid whetted Nancy's interest in western history. Moving to California's Gold Country was an opportunity to investigate a fascinating region and its colorful past. Her first magazine article was about a haunted Mother Lode hotel, and it was followed by others about the Gold Country. She has also authored *Haunted Hotels of the California Gold Country* for The History Press. After thirty-one years in the Golden State, she moved to Colorado, with its high mountain vistas and abandoned mining camps, remnants of later gold and silver rushes. Bouncing over rocky ledges and around narrow precipices on a challenging Jeep trail was a new thrill. Nancy says completing this book was as challenging as climbing a Fourteener (peak of fourteen thousand feet or higher).

Visit us at
www.historypress.net

This title is also available as an e-book